HOW TO DRAW MAGNIFICENT MAMMALS

EARL R. PHELPS

HOW TO DRAW MAGNIFICENT MAMMALS

By Earl R. Phelps

Copyright © 2006 by Earl R. Phelps

Published by
Phelps Publishing
P.O. Box 22401
Cleveland, Ohio 44122

Library of Congress Catalog Card Number: 2002-190074

ISBN 1-887627-06-5
13-ISBN 978-1-887627-06-1

Printed in the United States of America.

Visit our website at http://www.phelpspublishing.com

Table of Contents

Introduction

This is the first book of it's kind, on instructing you on how to draw the different mammals of the World. This book will not only focus on teaching you on how to draw the most spectacular mammals in the universe, but will give you some educational information about each species.

In this book, like in my previous books, I've created many step-by-step illustrations showing you how to draw these dynamic mammals of the world. This book has very few words, because as we all know a picture is worth a thousand words, so this book must contain over a million invisible words.

As you go through this book I want to give you a little guide line tip. When I draw the mammal's body, most of the time I'll start with the head then precede to draw the neck and other parts of the figure and so forth.

To truly become good at anything in life, you have to study, visualize, and perform, in other words, practice, practice, and more practice, ain't nothing to it, but to do it!

Earl R. Phelps
Cleveland, Ohio

I started drawing the tree limb first then proceeded with drawing an outline of the Two-toed Sloth's head, torso (middle part of the body), neck, arms and claws.

Note: The torso is the trunk of a body less head and limbs.

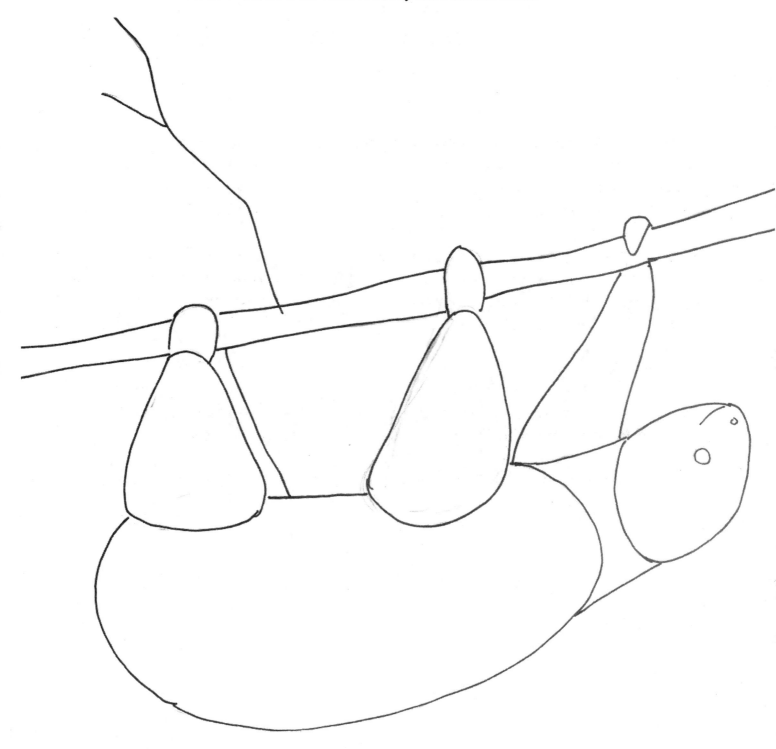

I have sketched in more form to the Two-toed Sloth's head, torso, neck, arms and claws to create more detail.

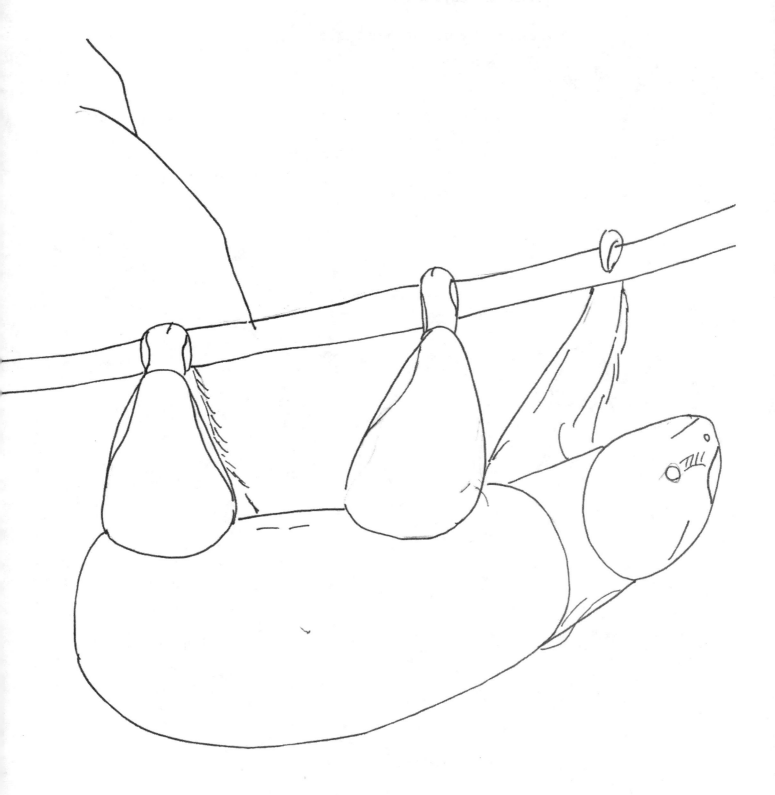

I have sketched in more form to the tree limb as well as adding hair to the Two-toed Sloth's head, torso, neck and arms to almost compete the drawing.

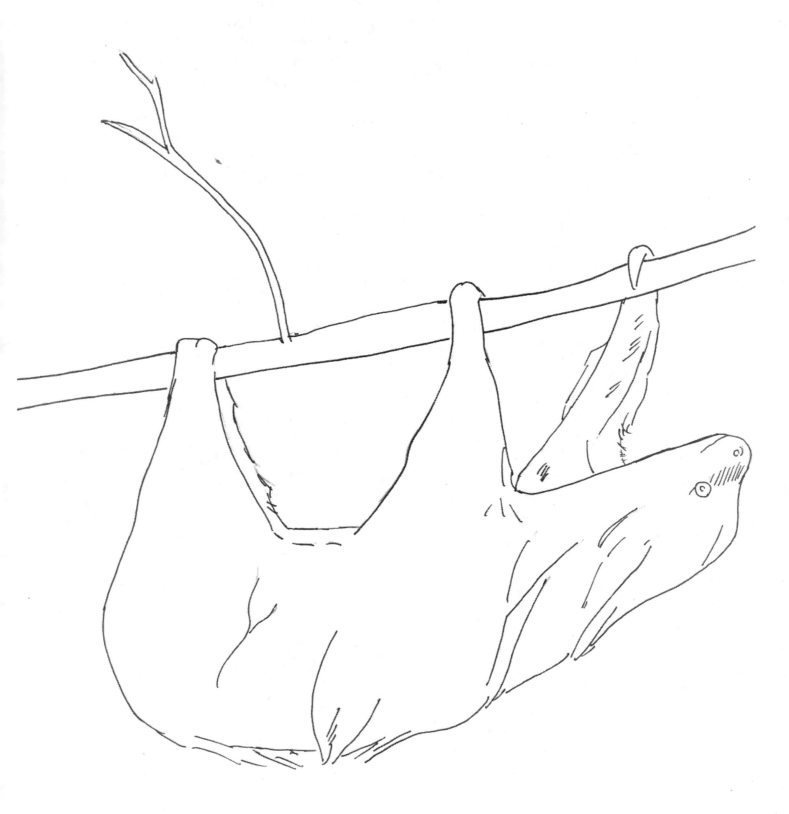

TWO-TOED SLOTH

TWO-TOED SLOTH the face is quite flatten and hairless, the eyes are small, set within black rings; the ears are also small and almost completely hidden beneath the long, gray-brown coat. The tail is a little more a stump. The front legs are slightly longer than the hind legs, and have feet with long curved claws. Length of head and body is about 25 inches, and weight is about 20 pounds.

This species has a vegetarian diet. It lives in tees, rarely descending to the ground, and spends much of its time hanging from branches, or resting in the fork between branches. A single offspring is born after a 5 to 6 month gestation period. In the first four weeks of its life the young sloth remains firmly attached to its mother, hidden in her coat. At 9 months it is almost completely independent, but does not reach full maturity until two of age.

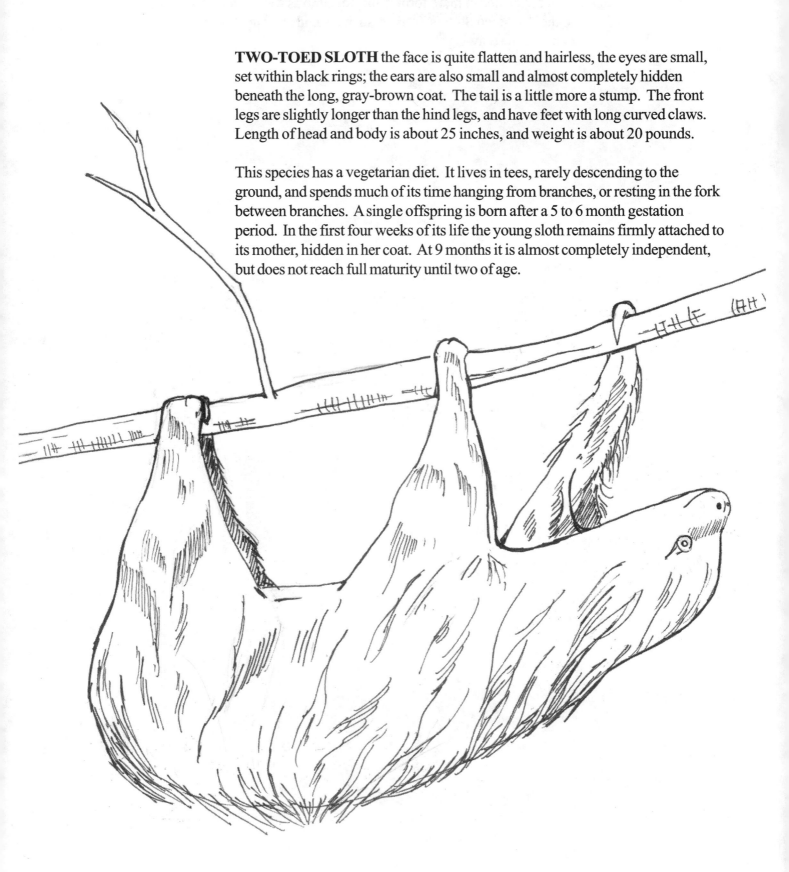

To start the show, I drew an outline of the Common Bat's
head, torso, and wings.

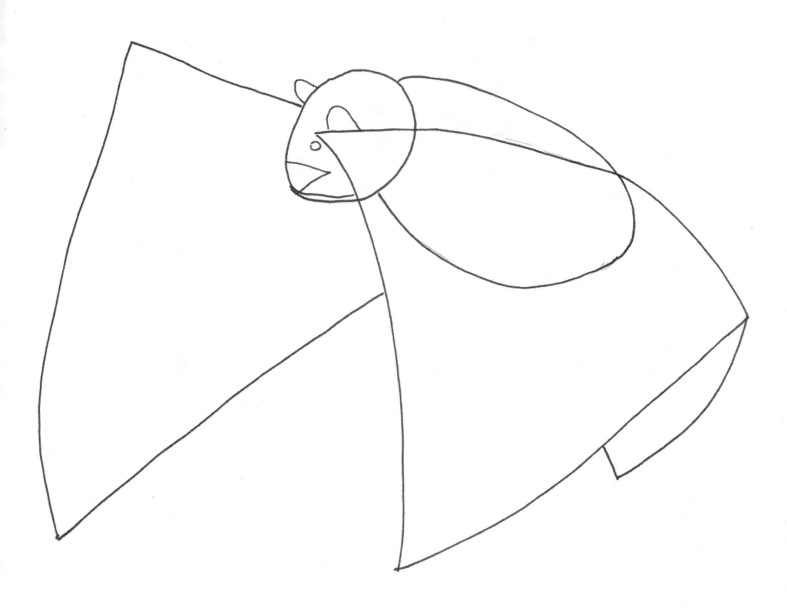

Now, you can sketch in some details to the Common Bat's head, torso, and wings.

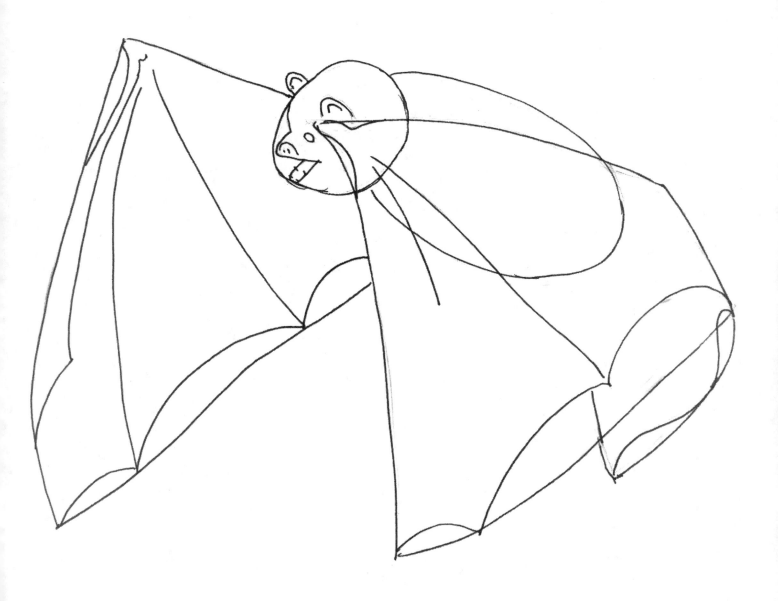

10

You've almost finished this drawing, just add more details to the
Common Bat's head, torso, wings, and outline for shadows.

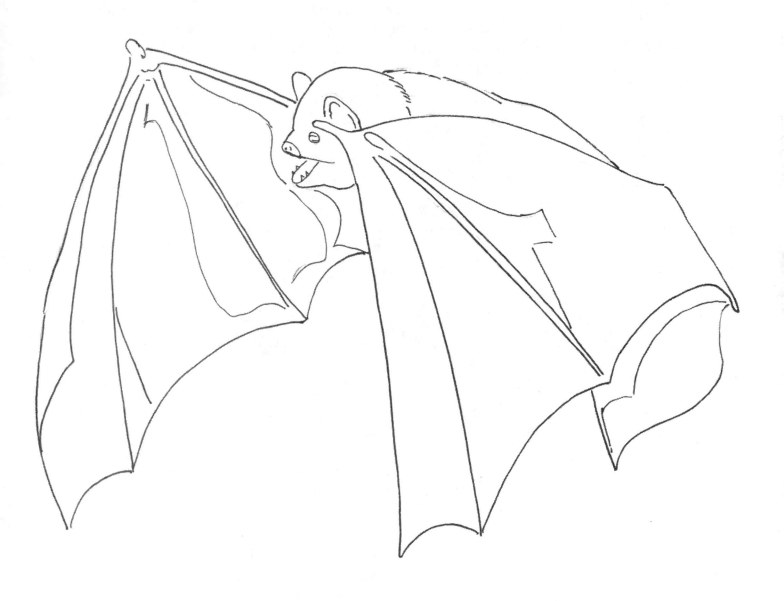

COMMON PIPISTRELLE BAT

COMMON PIPISTRELLE BAT small and robust, this bat has a short dark muzzle, small ears, with broadly rounded tip. Fur long, uniformly brown, may be slightly lighter beneath. Length of head and body about (1.6 in.), forearm about (1.2 in.), and weight (0.1 - 0.3 oz.).

This bat is found in Britain, southern Scandinavia, Western Europe to Caucasus; Morocco; Middle East to Kashmir. The most abundant bat in the British Isles and one of the most common in Europe, the tiny Pipistrelle roosts singly or in small colonies up to several hundred in number, often with other species. It favors hollow trees, or under loose bark, buildings, under roofs, but rarely found in caves. It forages throughout the night, and in spring and autumn may be seen flying about in midday as well, seeking small insects such as gnats. Common Pipistrelle hibernates in winter and sometimes migrates more than 1000 miles between seasonal roosting sites. Most young are born in July after a gestation period of about six weeks, and reach sexual maturity in two years. A single offspring is usual in Britain; twins are common in northern and central Europe.

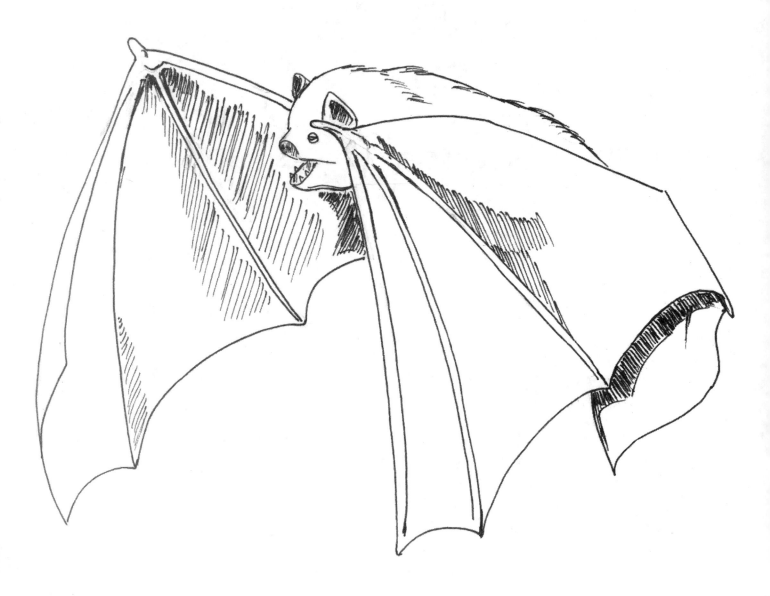

Let's first start drawing an outline of the Markhor's head, horns, neck, torso, tail, legs and hoofs.

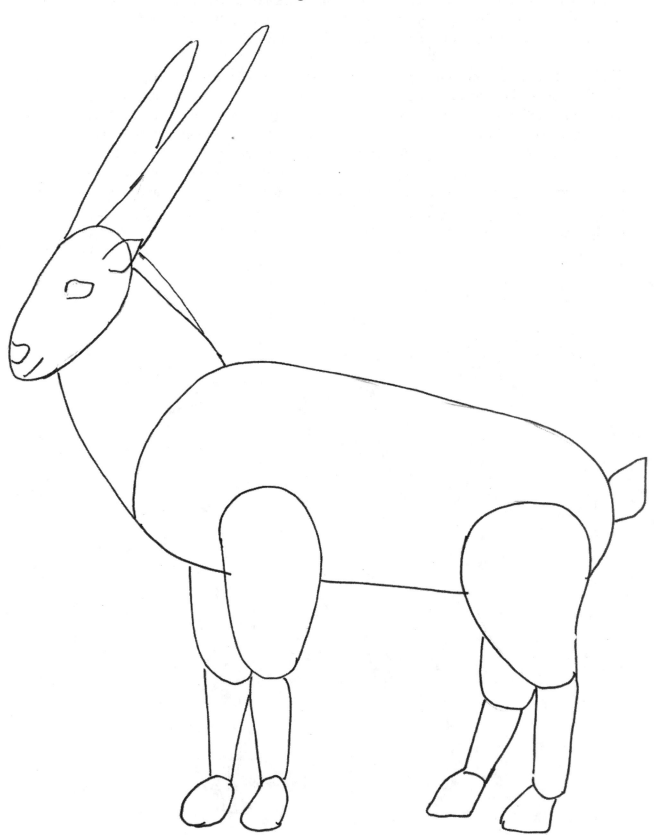

Sketch in more details of the Markhor's head, horns, neck, torso, tail, and hoofs.

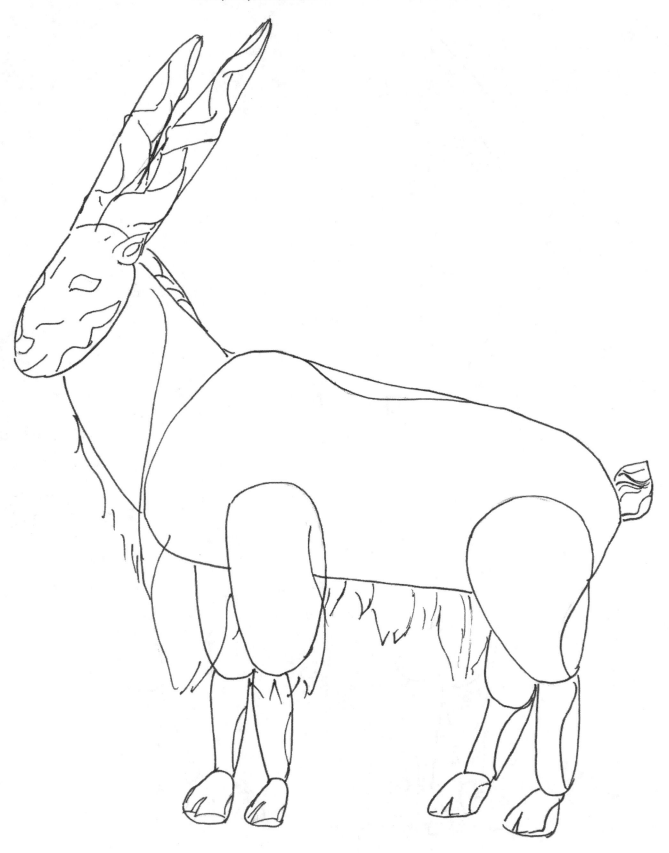

You can erase any lines not needed, draw in hair and add more details to the Markhor's head, horns, neck, torso, tail, and hoofs.

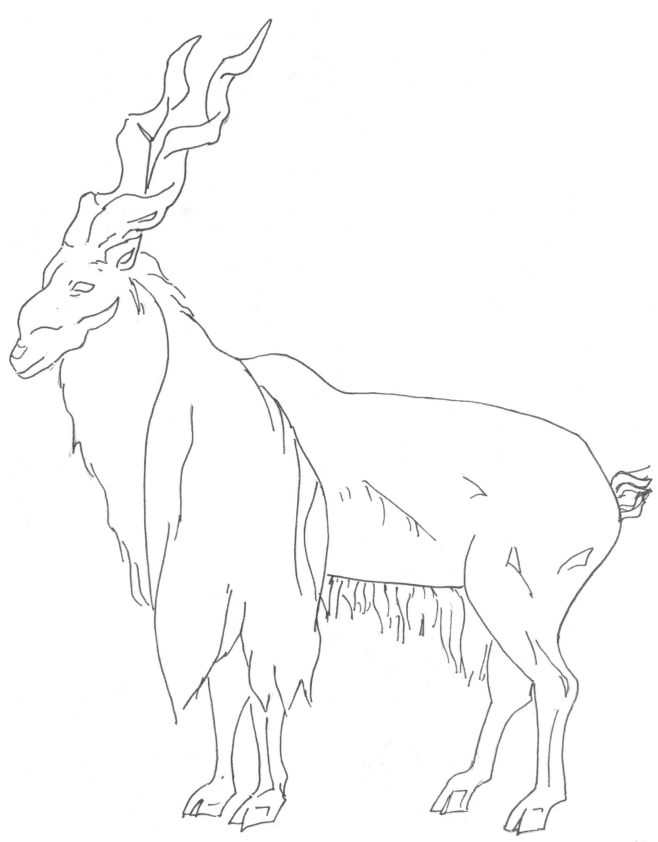

MARKHOR

MARKHOR the coat is short and smooth in summer and longer in winter, it is heavier in the northern part of its range. The males have a long beard on the chin and long hair on the throat, chest, and shanks; female have smaller fringes of long hair. The horns, which are present in both sexes, are spiral shaped, and are much smaller in the female. Length head and body is 64 to 67 inches, tail about 3 to 5 inches, and weight about 176 to 242 pounds; females smaller than males.

This creature is found in Afghanistan and the western Himalayas. Although one of the largest of the Caprinae, or wild goat, this usually solitary, nimble creature climbs and jumps over mountain terrain with ease. In the winter months it descends to lower altitudes to avoid extreme cold. Mating occurs in the winter. In the summer the females gather in small groups, which include the newborn. Gestation lasts for 5.5 months, and then the female delivers 1 or 2 kids. The numbers of this species has been considerably reduced because of hunting, and because of epidemics transmitted to them by domestic animals

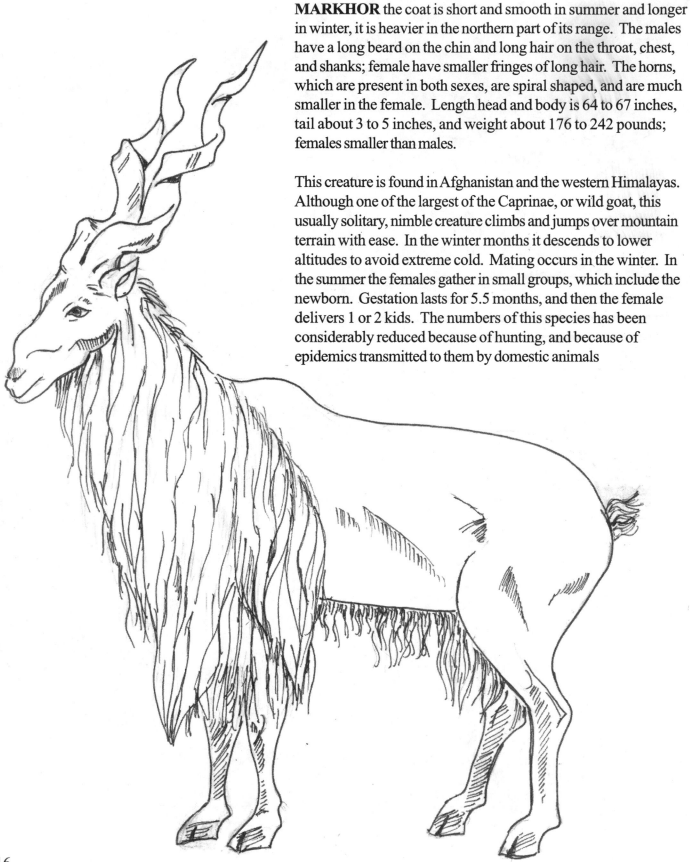

I started drawing an outline of the Walrus's head, neck,
tusks, torso, and the rest of the body.

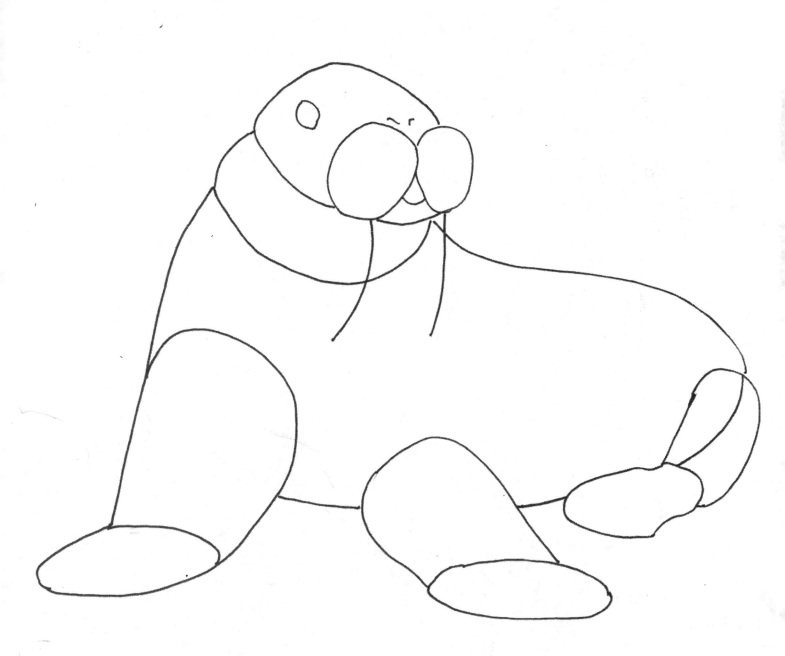

Sketch in more portions of the Walrus for a more precise
description of the total body.

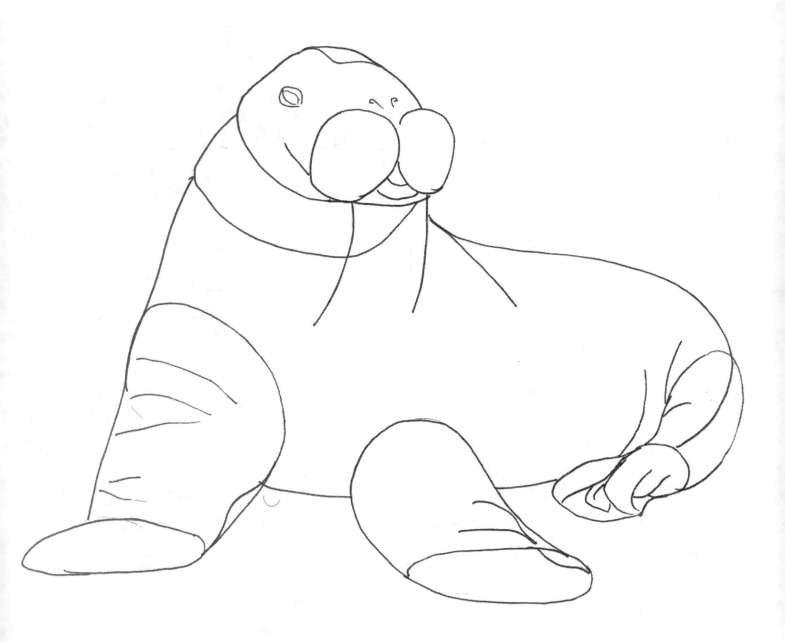

Add more details, such as forming the tusk, whiskers across the snout, wrinkles and you're almost there.

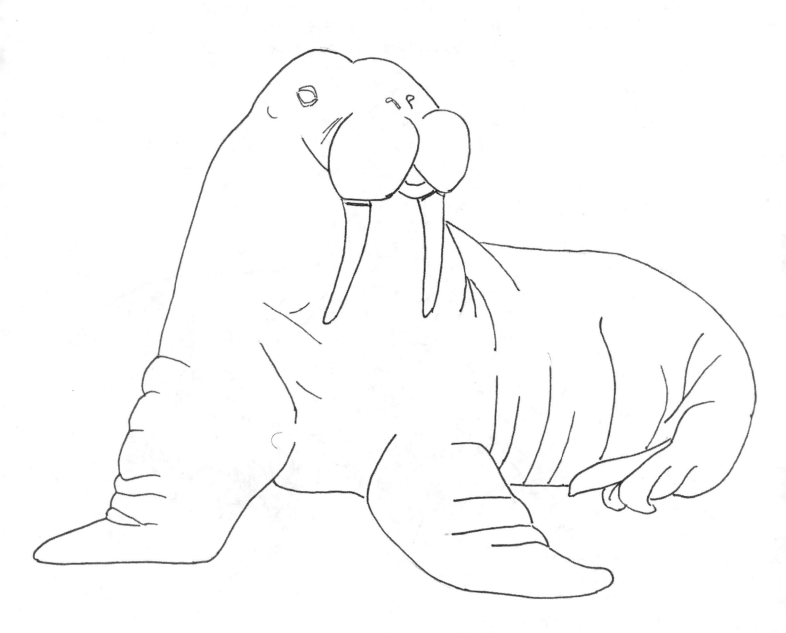

WALRUS

WALRUS the brown coat can be quite thin, and in older individuals the skin is completely bare. A layer of fat about 2-3 inches thick provides insulation. There are many stiff whiskers across the snout. There is no external ear. The upper canines form two tusks that can reach a length of 35 inches and which cause the entire structure of the cranium (skull) to be altered. The other 18 to 24 teeth are similar to each other. Total head to body length up to 12.5 feet, and weight over 2600 pounds with females being much smaller.

Founded in North circumpolar this gregarious species lives in large groups. It spends most of the day sleeping on ice. It usually flees if attacked, but there have been cases of walruses attacking the boats of Eskimos. A cow will vigorously defend her young. It feeds largely on mollusks, which it may wrench from the seabed with its tusks. Females breed every other year, and after an 11-12 month gestation, 1-2 young are born in April-June. The females become sexually mature at 4-5 years and the males at about 7 years.

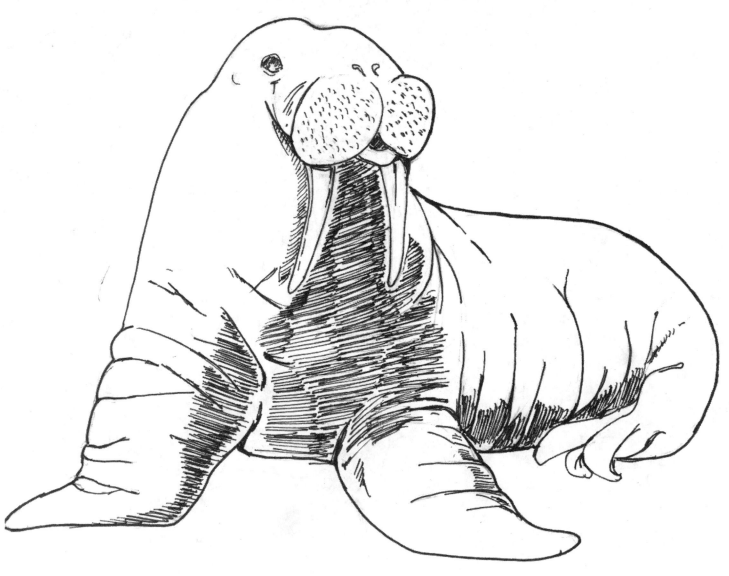

Let's start an outline of the Giraffe's head,
neck, torso, tail, legs, and feet (hoofs).

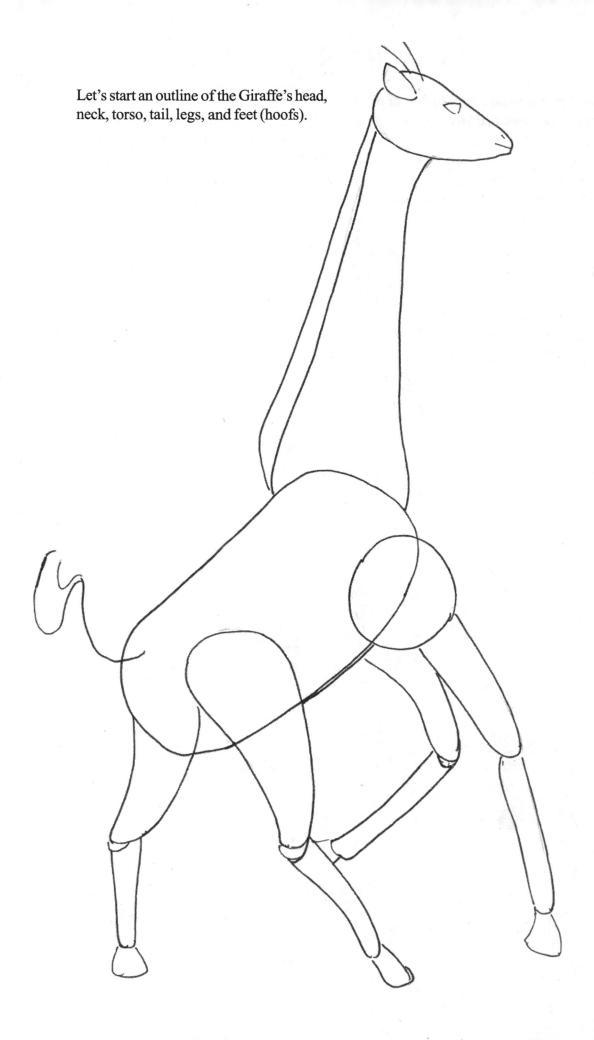

Now, you can sketch in some details to the Giraffe's head, neck, torso, tail, legs, and feet (hoofs).

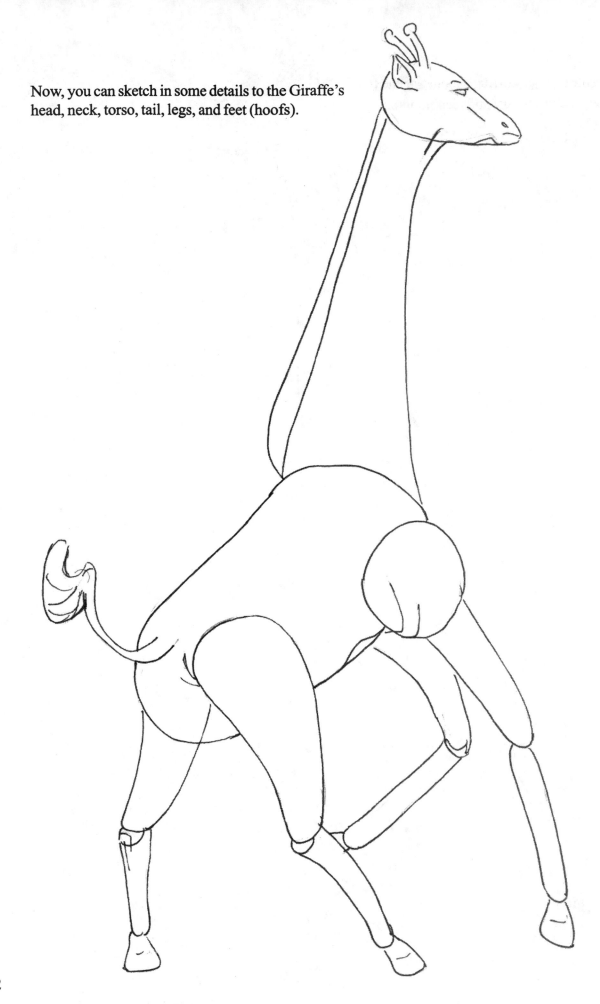

Continue to draw in more details including the coat pattern made up of brown spots.

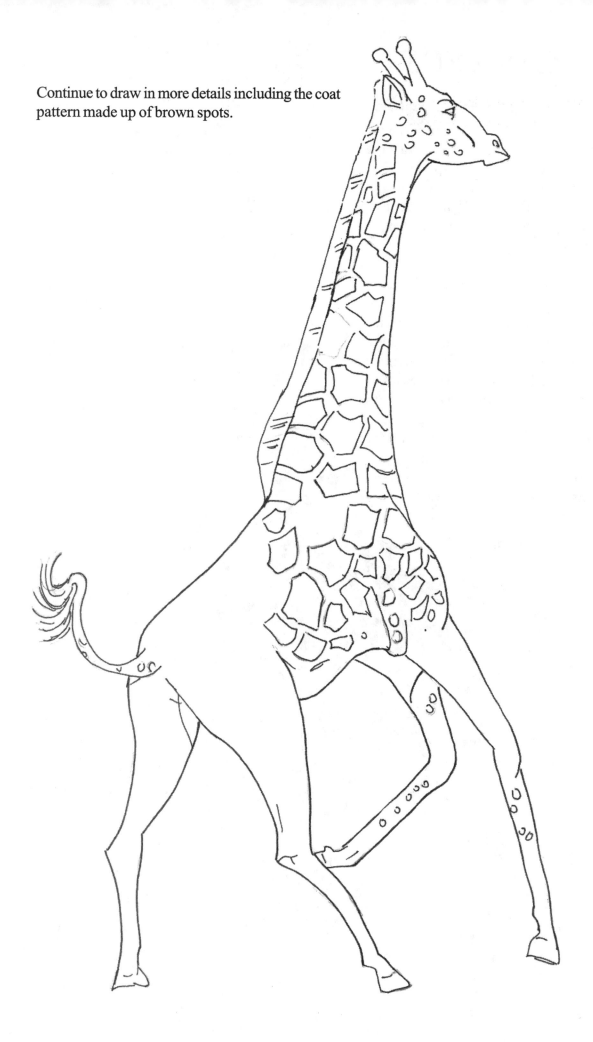

GIRAFFE

GIRAFFE is the tallest living animal. The coat pattern is made up of brown spots of varying sizes, separated by a network of light-colored lines. This pattern varies a great deal between the different geographical subspecies. The giraffe has two small horns and a medium bulge on its forehead, which is covered with skin and hair. Shoulder height about 11.5 feet, height to head up about 20 feet, and weight up to a little over a ton.

Found in sub-Sahara Africa this creature lives in herds, which can number up to 30 to 40 individuals. The group is dominated by an old bull giraffe, but is led by a female when on the move. Sometimes exclusively male groups are formed. The giraffe is vegetarian, and feeds on spiny or thorny plants, which it handles easily with prehensile upper lip and long tongue. When it walks it has an ambling gait, but when it runs it move its front legs together and its back legs together, in sequence. Giraffes breeds year round and give birth after a 15-month gestation to a single young. The offspring nurses for about a year, but begins to eat after a few weeks. The female reaches sexual maturity at 3.5 years of age, the male at about 4.5 years.

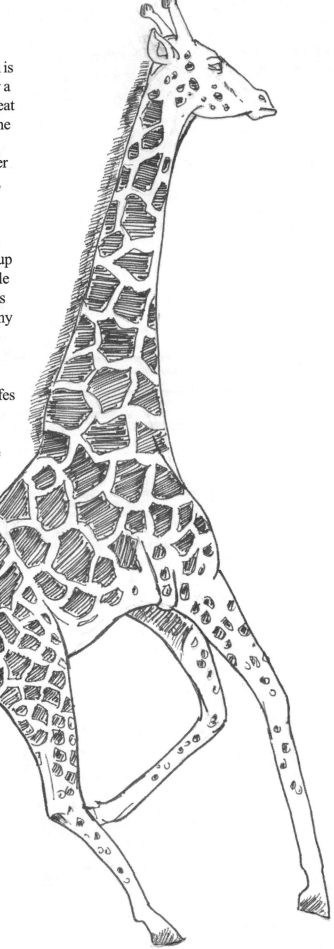

You can start an outline of the Laughing Hyena's head or torso with this figure, and then proceed with the tail, legs, and feet (paws).

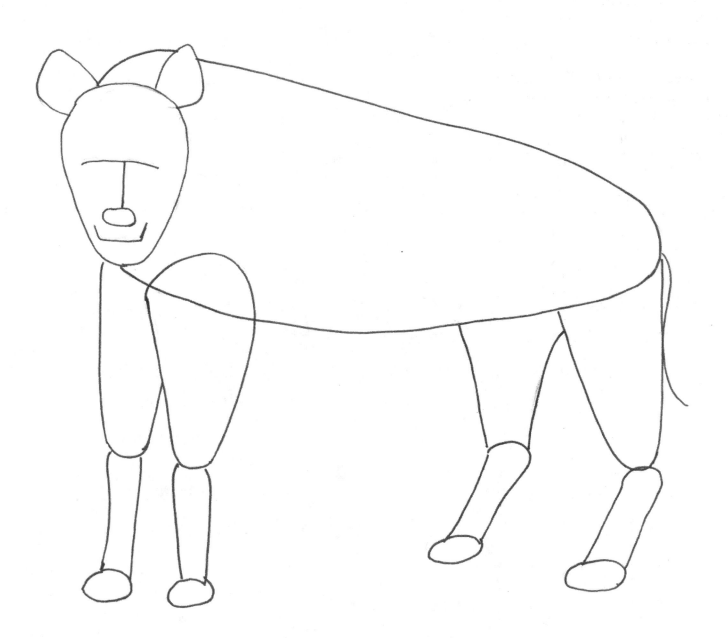

Shape the outline for a more precise figure of the head,
torso, tail, legs, and feet.

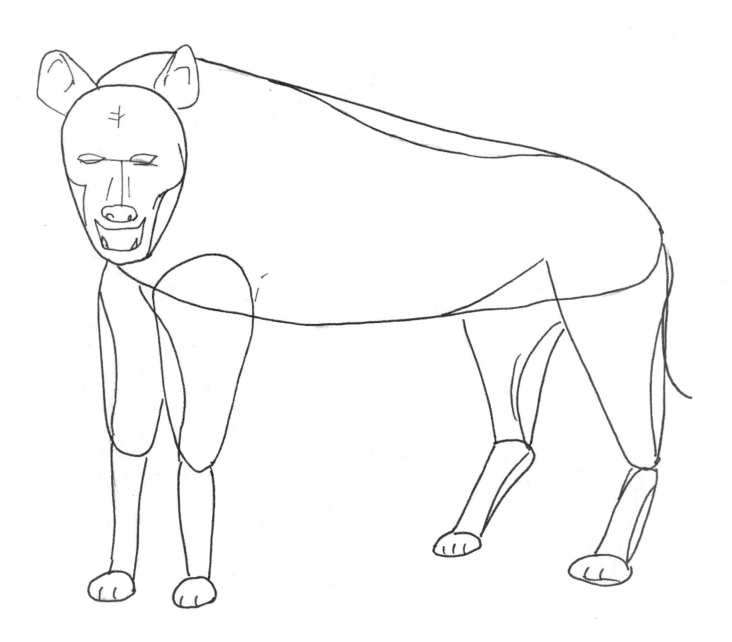

Erase any unneeded lines and put in more details including the Laughing Hyena's coat pattern made up of dark spots.

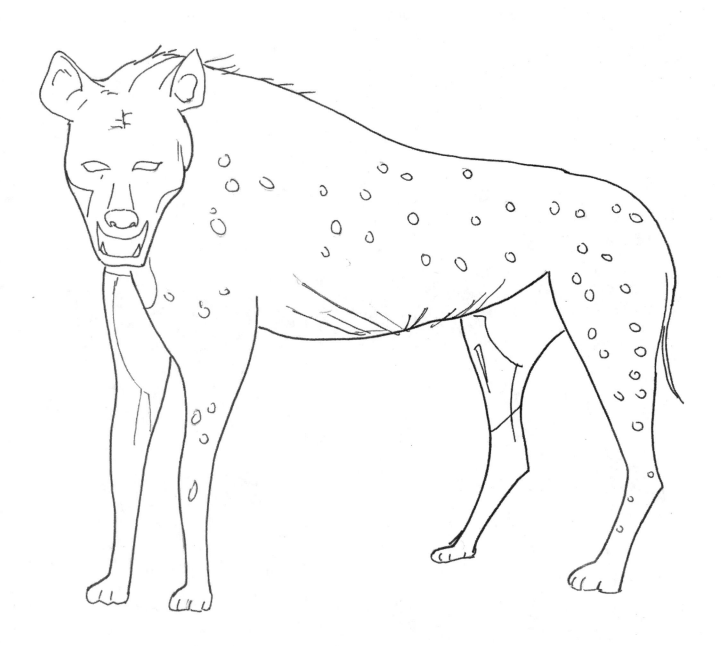

LAUGHING HYENA

LAUGHING HYENA is the largest of the hyenas, with powerful body, large head, large eyes, and rounded ears. The color of the coat is variable but tends to brown, yellow, and gray with numerous dark spots. They are found in Sub-Saharan Africa except densely forested areas and the southern tip of the continent. Length of head and body 4.3 - 5.3 feet, tail 10 - 12 inches, weight 130 - 180 pounds

This hyena is generally a night creature, but does move around during the day. It lives alone or pairs. It patrols a large territory and often follows large plant eating creatures. It feeds on carcasses, but can attack and tear apart animals the size of a gnu (wildebeest). During the courtship and mating period it sometimes gathers in large packs, which are quite noisy. The gestation period lasts for about 110 days, after which 1 or 2 young (rarely 3) are born. The offspring nurse for about 18 months.

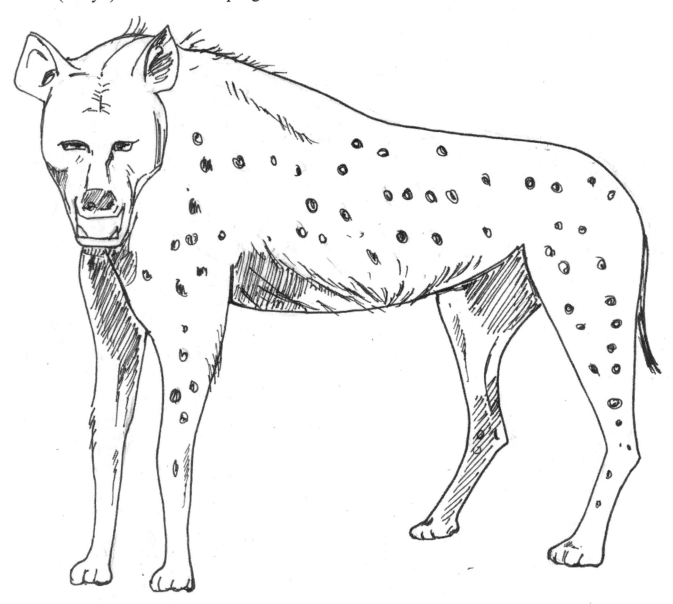

I'm sure you have figured out by now from the lessons of previous pages of this book, that when you start the drawing of a mammal most of the time you will start with head, unless it is in different position such as the backside of the mammal.

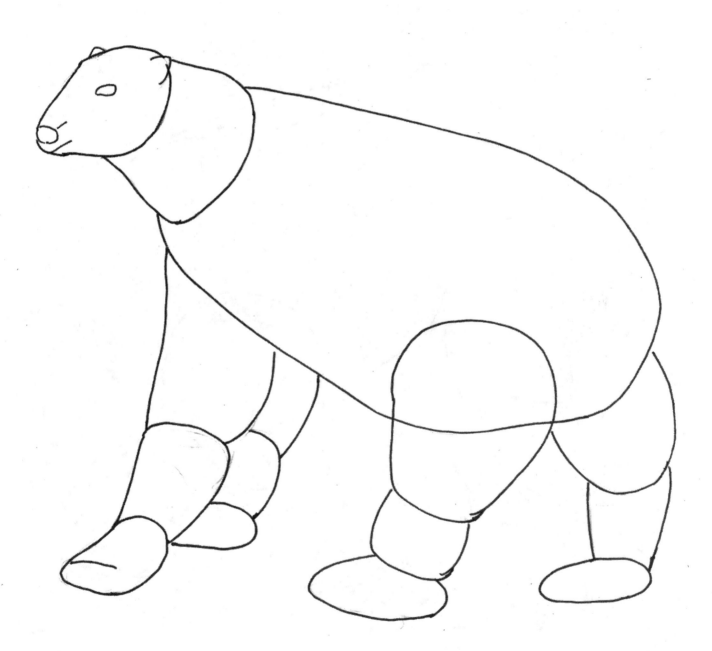

Shape the outline of the Polar Bear for a more precise figure
of the head, torso, tail, legs, and feet.

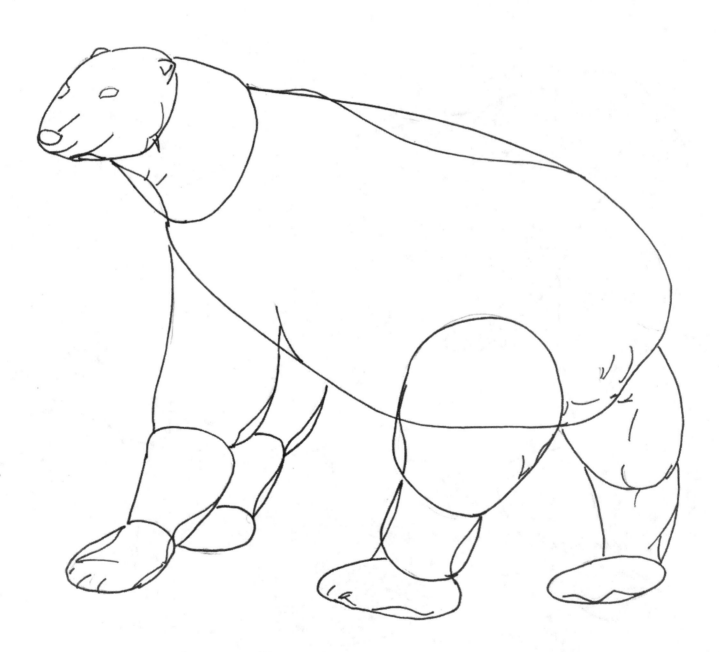

You can erase any lines not needed, draw in more details to the Polar Bear's head, neck, torso, tail, feet, and don't forget to put on its fur coat because it's cold out here.

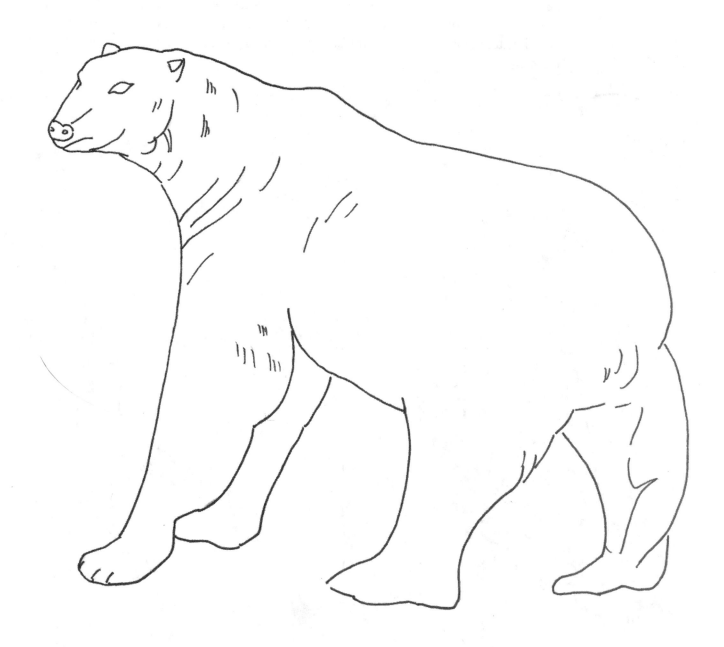

POLAR BEAR

POLAR BEAR may be the largest of land carnivore, but compared to other bears, the polar bear has a slender body covered with thick yellowish white fur, and a small head set on a long neck. The hind legs are longer than the front legs, which cause the back to slope forward. The length of head and body measures 7.2 - 8.2 feet, shoulder height up to 5.3 feet, weight over 1100 pounds.

The polar bear is solitary. Pairs are only formed for a few days while mating takes place from April to May. In October, the female leaves the floes and hides in a den dug out on ice on land. The young are born in December, but the mother and her cubs do not emerge from the den until April. The mother nurses her cubs (usually 1 - 3) for 18 months. Adult polar bears wander from ice floe to ice floe, but do seem to have a favorite hunting ground. It feeds on seals and fish. A good swimmer, it paddles with its front legs only.

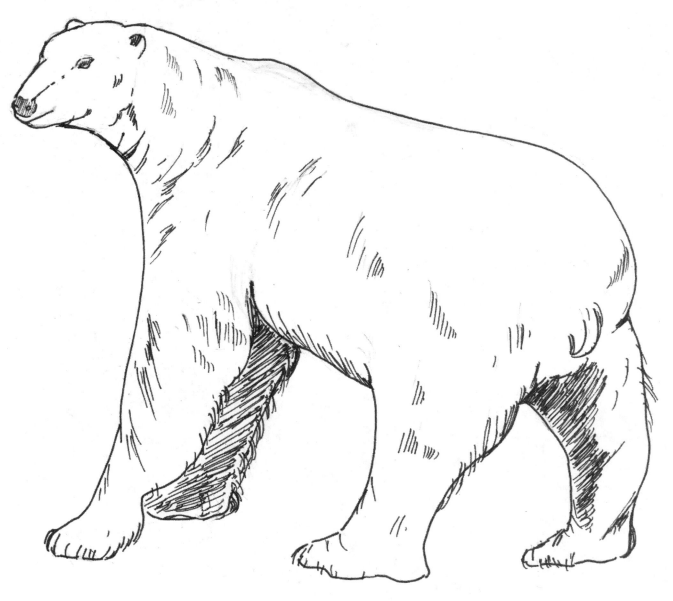

Let's get busy drawing this White Rhinoceros. Let's start with
an outline of the head, horns, neck, torso, leg, and feet.

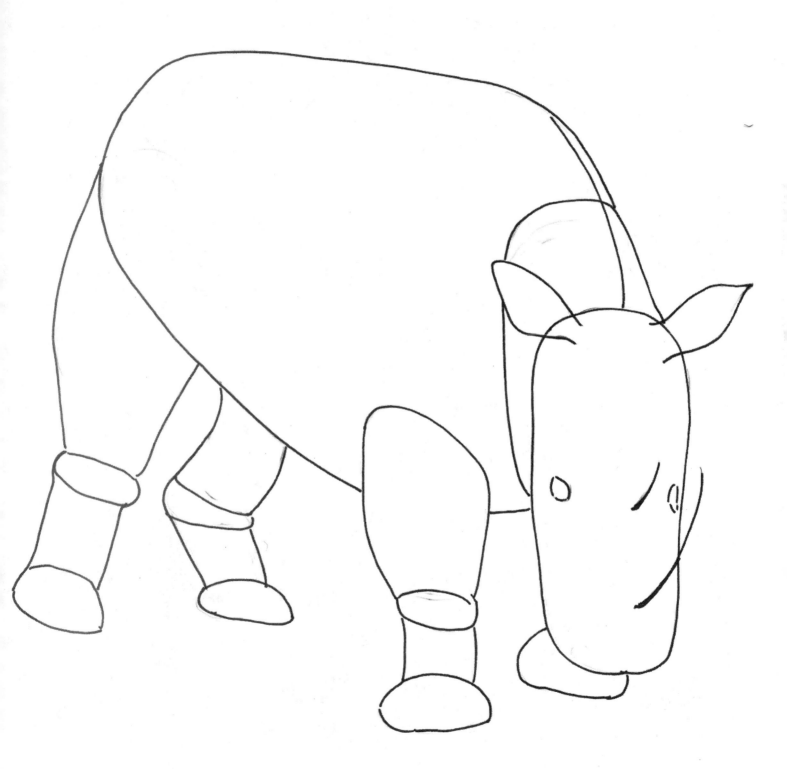

Now, let's define the various parts of the White Rhinoceros's body by drawing within the outlines.

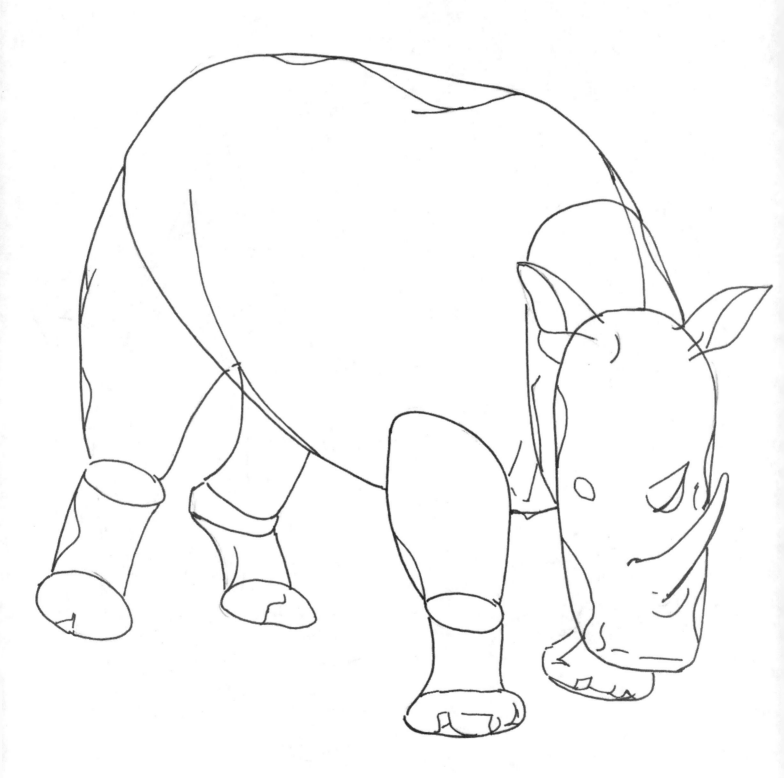

You can erase any lines not needed, draw in more
details such as the wrinkles and shadows.

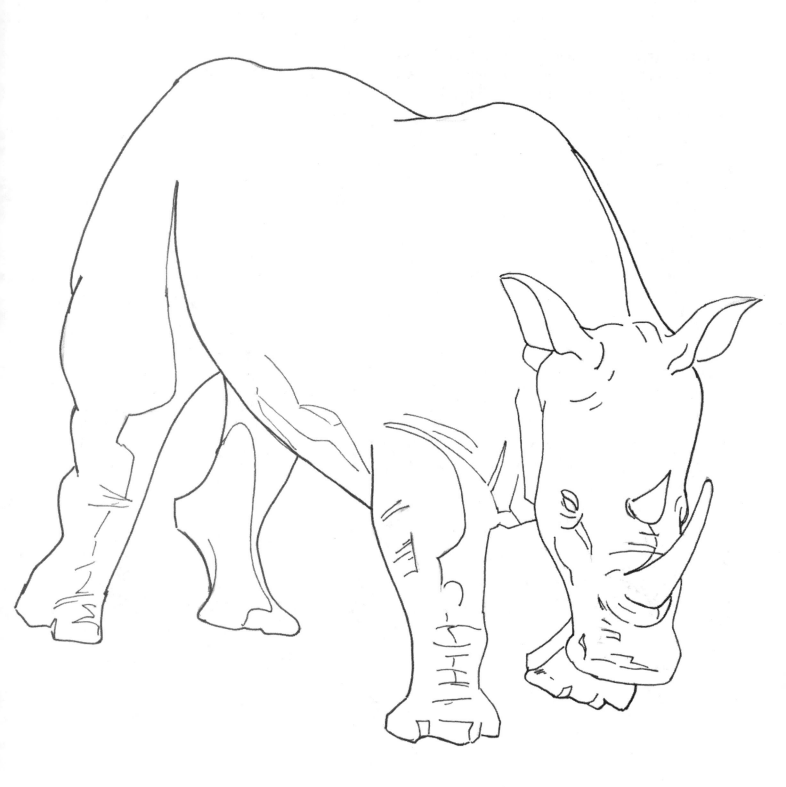

WHITE RHINOCEROS

WHITE RHINOCEROS is larger and heavier than the black rhinoceros and can be readily identified by the hump on the nape of its neck. The head is carried low. The horns are longer and thinner up to 65 inches. The ears are broad and have hairs on the edges. The upper lip is square shaped. Length of head and body up to 12.5 feet, shoulder height up to 6.1 feet, weight about 3.5 — 4 tons.

The white rhinoceros resides in the grasslands, swamps, and rivers of Southern Sudan and South Africa. This is the largest of land mammals other than the elephants. It is less aggressive than the black rhinoceros. It rarely charges and males only engage in combat during mating season. The males are usually solitary, but females with calves may be seen in groups. It feeds on grass and needs water daily, and often wallows at length. It moves slowly and always uses the same tracks and paths. It is active both during the day and at night. It has poor sight, but has acute hearing. The female has only one calf every 3 - 4 years after an estimated 17 - 18 month gestation.

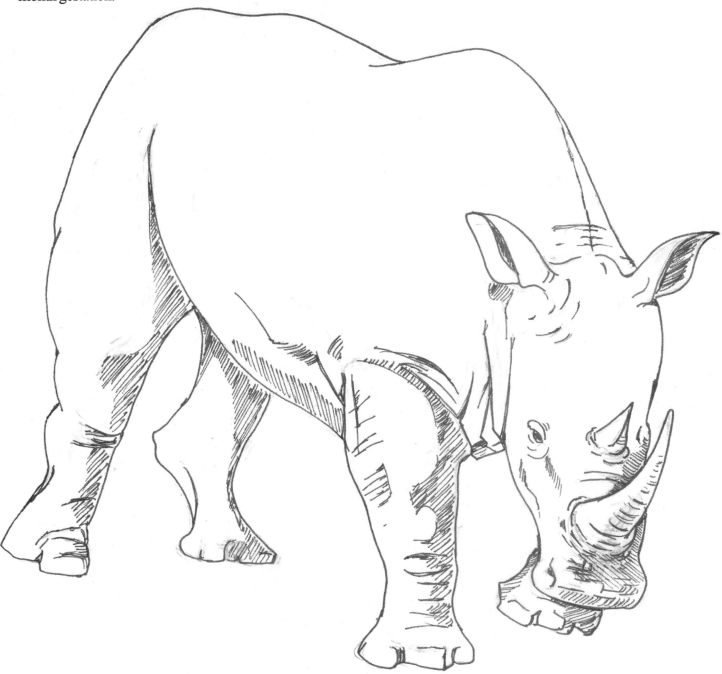

You can start to draw an outline of the Elephant's head, tusks, trunk, ears, torso, legs, and feet.

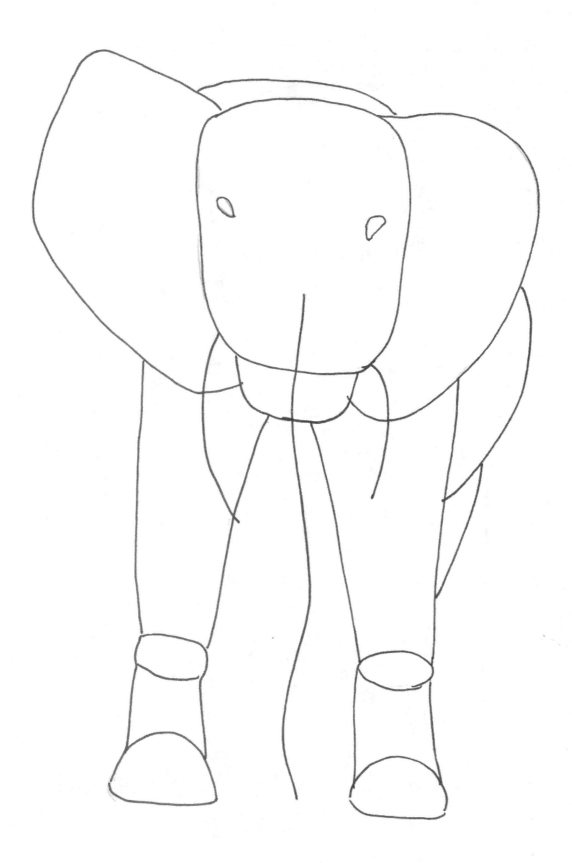

Sketch in more portions of the Elephant for a more precise description of the total body.

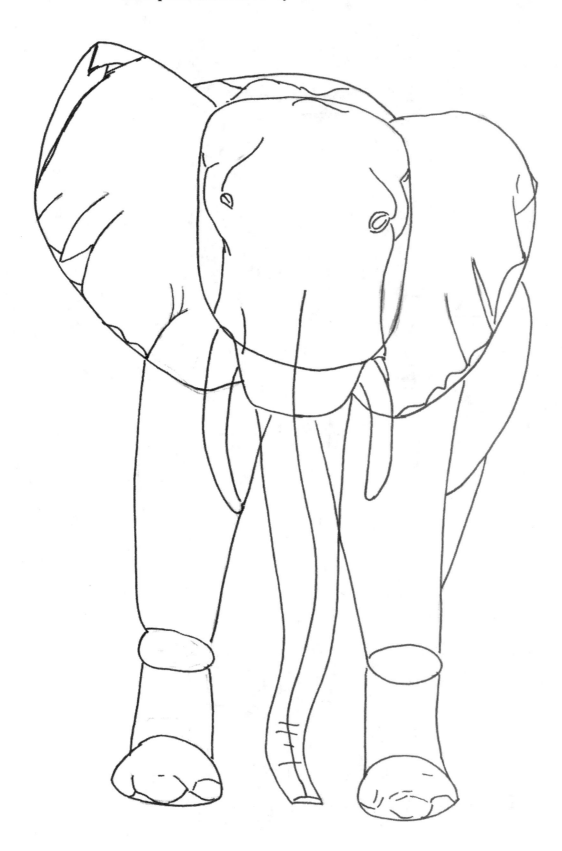

You can erase any lines not needed, draw in more details of
the elephant such as the wrinkles and shadows.

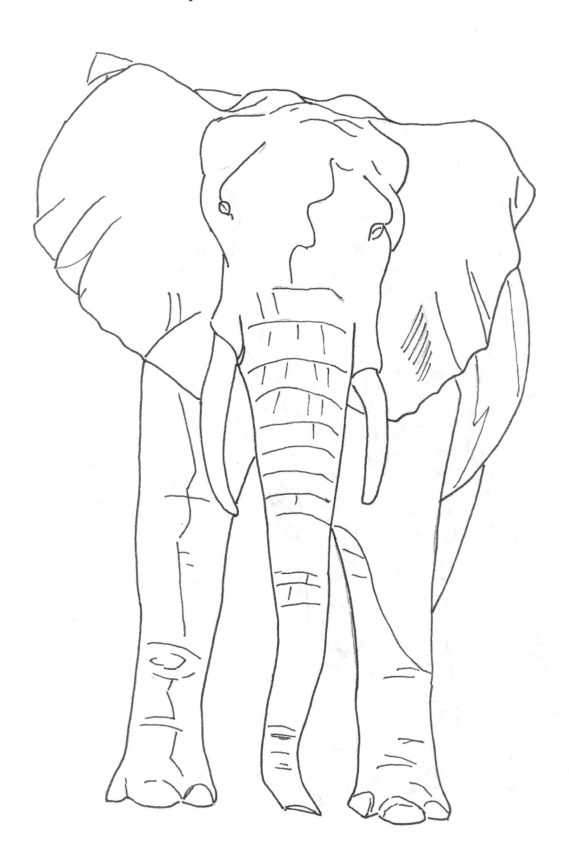

AFRICAN ELEPHANT

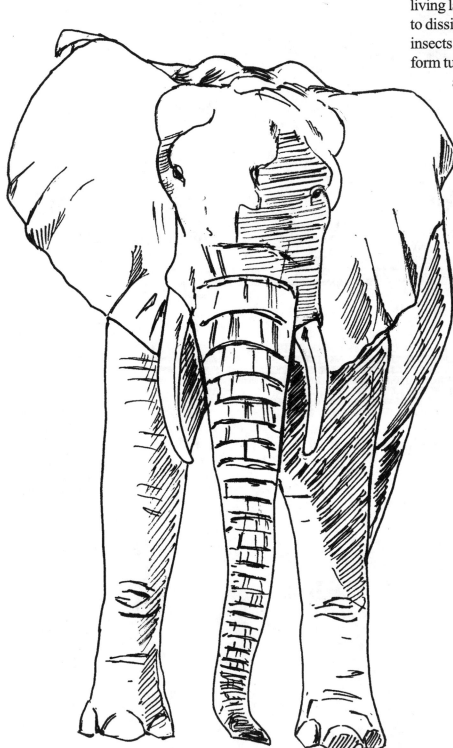

AFRICAN ELEPHANT this is the largest living land mammal. Its enormous ears serve to dissipate body heat and brush away insects from its eyes. The upper incisors form tusks, which average about 5 foot long and weigh about 35 pounds. Length of head and body including trunk up to 25 feet, shoulder height to 13 feet, weight may exceed 6000 tons.

This creature is found in Sub-Saharan Africa except southern Africa. This elephant is a social animal living in family groups, which have a matriarchal structure. The head of the group is an elderly female: she makes decisions about when and where to move, and keeps the peace. Groups of African elephants can number more 100 individuals in periods of drought. The groups are constantly moving when the animals are feeding. The elephant must drink daily, and enjoy bathing in waterholes. Breeding occurs all year, but a female will only give birth once every 4 years. Gestation lasts for 22 - 24 months, at the end of which a single offspring is born, weighing about 220 pounds. It nurses for 2 - 3 years.

Let's first start drawing an outline of the Wart Hog's head,
ears, horns, neck, torso, tail, legs and hoofs.

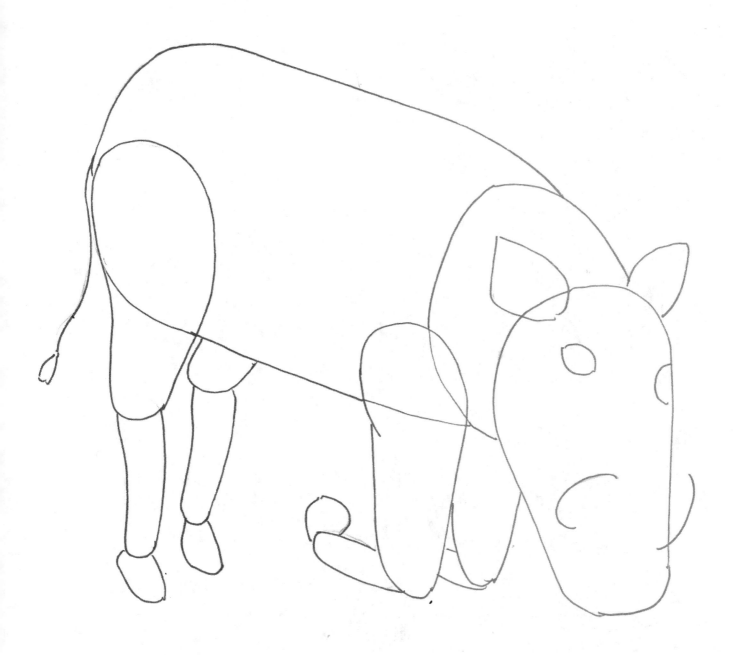

Sketch in more portions of the Wart Hog for a more precise description of the total body.

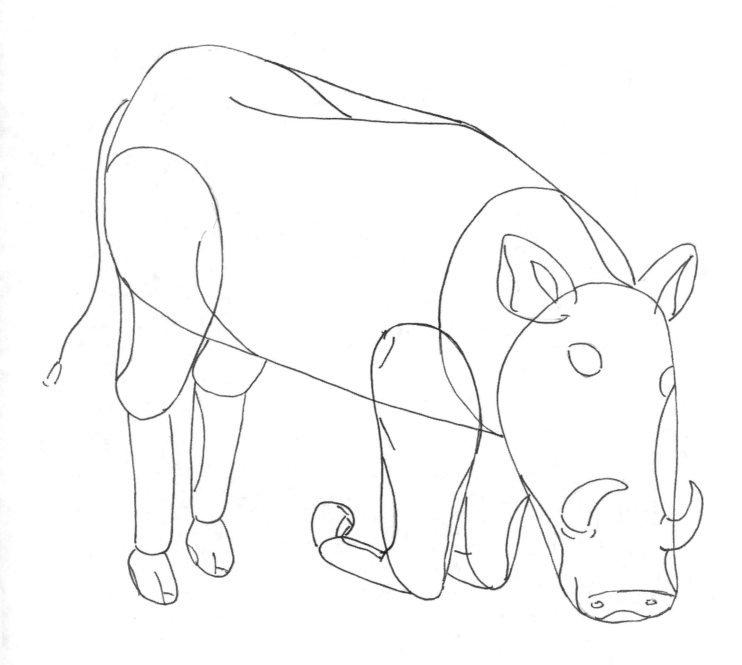

Now, let's define the various parts of the Wart Hog's body by drawing within the outlines.

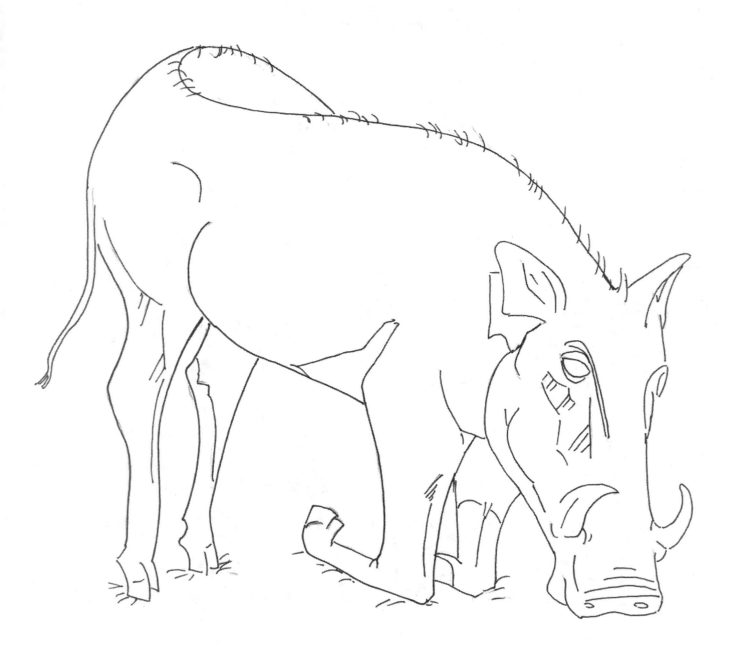

WART HOG

WART HOG the adult color is blackish, brownish, or grayish, the young are pinkish. The hide is almost hairless with only a few hairs present on the cheeks and on the back where they form a mane. The tail is long, has a tuft of hair at the end, and is carried in a distinctive vertical position when the animal is moving. The head is disproportionately large and has two pair of large warts. The tusk form a semicircle between them pointing forward and upward. The lower canines are extremely sharp. Length of head and body about 40 inches, shoulder height 25 - 30 inches, and weight 165 - 220 pounds with females somewhat smaller.

Found in the Sub-Saharan Africa the wart hog usually lives in small family groups, but several families will often band together temporally to form larger herds. They spend the hottest part of the day sheltered by vegetation or in its den. It is vegetarian and can often be seen grazing in a characteristic kneeling position. It feeds mostly on short grasses and herbs. It does not damage crops, and prefers to remain away from areas where there is human activity. Its main enemies are lion and leopards. After about 175 days of gestation 2 - 4 young are born which nurse for a few months and become independent about 1 year after birth

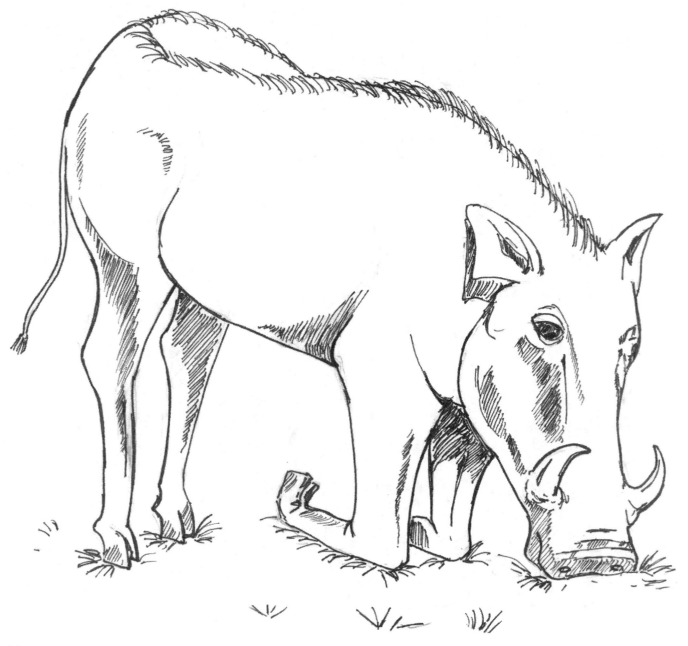

I started drawing the tree first then proceeded with drawing an outline of the Leopard's head, neck, torso legs, and claws.

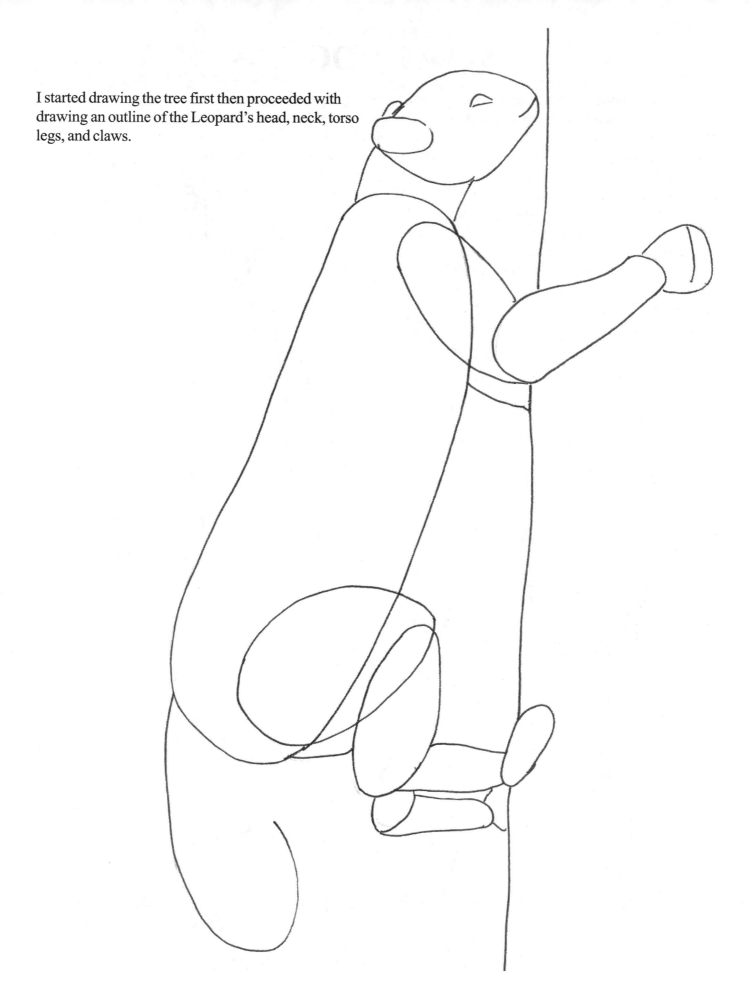

Sketch in more portions of the Leopard for
a more precise description of the total body.

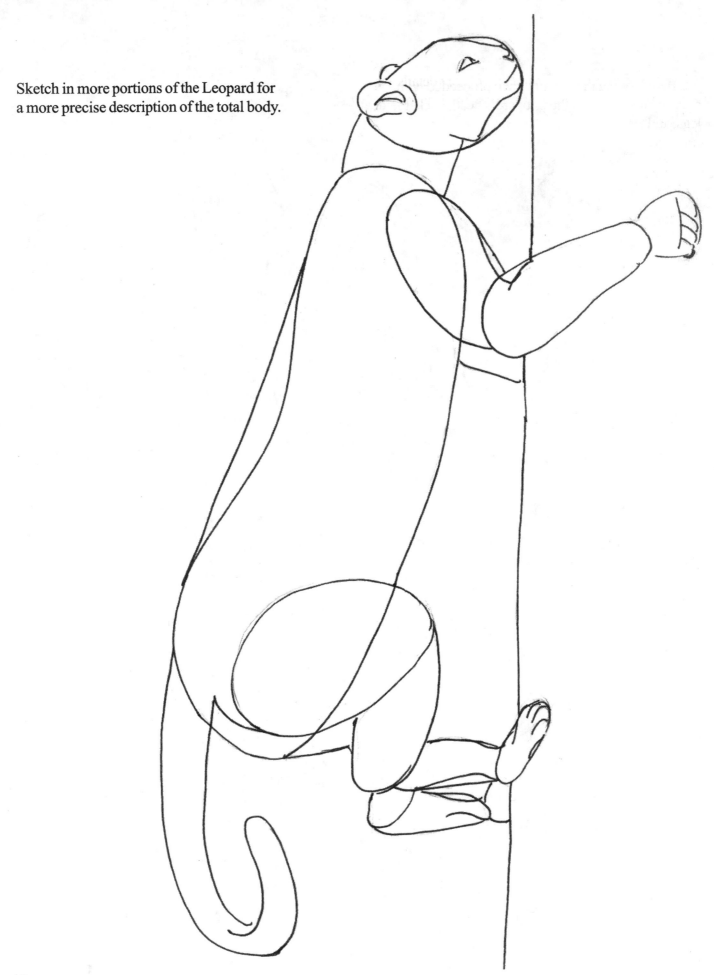

Erase any unneeded lines and put in more details including the Leopard's coat pattern made up of dark spots.

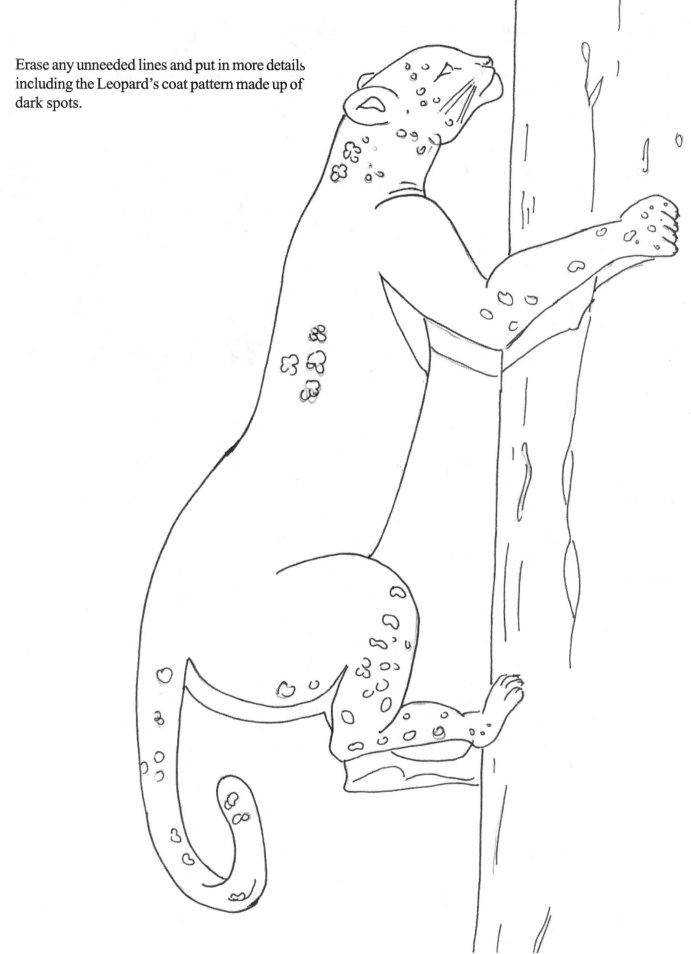

LEOPARD

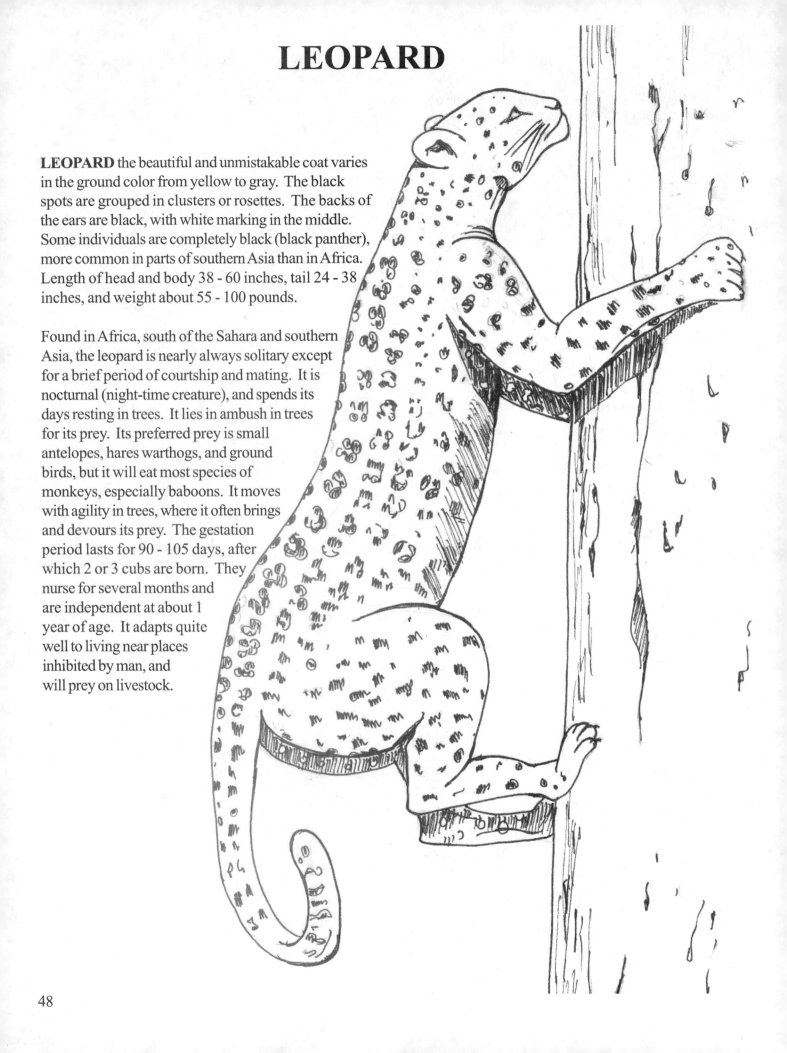

LEOPARD the beautiful and unmistakable coat varies in the ground color from yellow to gray. The black spots are grouped in clusters or rosettes. The backs of the ears are black, with white marking in the middle. Some individuals are completely black (black panther), more common in parts of southern Asia than in Africa. Length of head and body 38 - 60 inches, tail 24 - 38 inches, and weight about 55 - 100 pounds.

Found in Africa, south of the Sahara and southern Asia, the leopard is nearly always solitary except for a brief period of courtship and mating. It is nocturnal (night-time creature), and spends its days resting in trees. It lies in ambush in trees for its prey. Its preferred prey is small antelopes, hares warthogs, and ground birds, but it will eat most species of monkeys, especially baboons. It moves with agility in trees, where it often brings and devours its prey. The gestation period lasts for 90 - 105 days, after which 2 or 3 cubs are born. They nurse for several months and are independent at about 1 year of age. It adapts quite well to living near places inhibited by man, and will prey on livestock.

Start drawing an outline of the Dingo's head, ears, neck, torso, tail, legs, and paws.

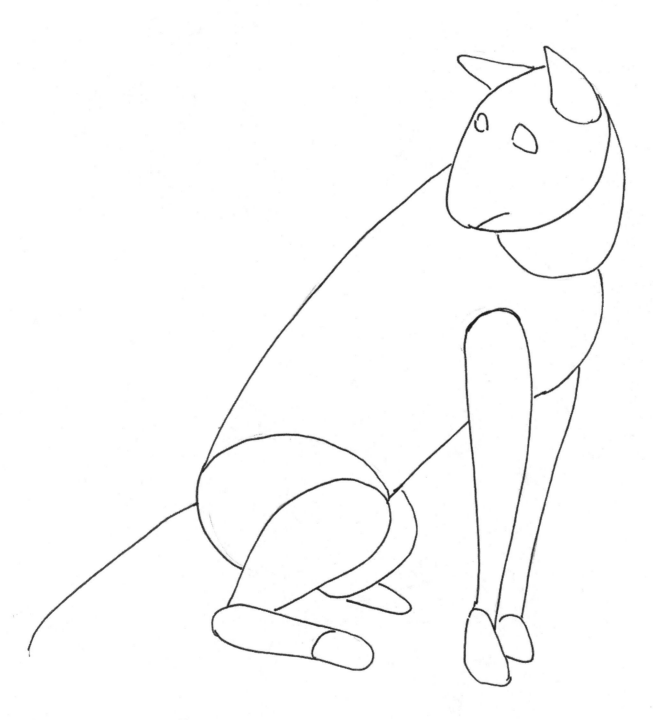

Begin shaping in the outline of the Dingo for a more precise description of the total body.

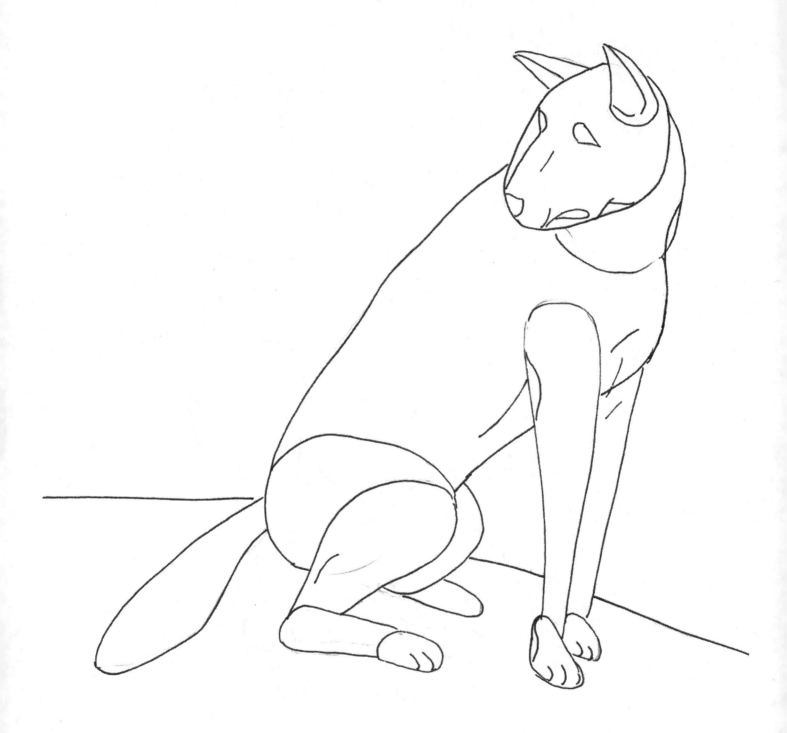

Get rid of any unnecessary lines to proceed to turn your
drawing into a masterpiece.

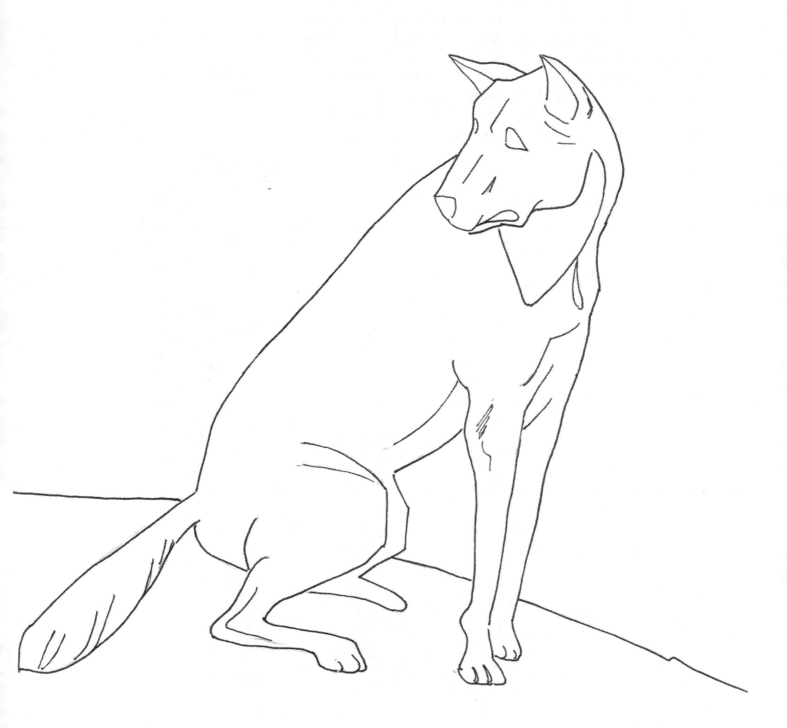

DINGO

DINGO it resembles a large yellow dog: the color is more or less uniform, sometimes with reddish or beige highlights. The dingo is found in the scrub and semidesert environment of Australia. The dingo generally leads a solitary life or lives in pairs. Sometimes, but not regularly, large packs are formed, this is useful when hunting large kangaroos. Once the rabbit was introduced into Australia it became the dingo's primary prey, followed by smaller marsupials. The dingo reproduces once a year, and not twice like the domestic dog. Gestation lasts for 2 months and the female gives birth to 5 - 7 pups in early spring. The pups are reared by both parents, and within a pack, all adult members participate in their care. Length of head and body up to 44 inches, tail 10 to 16 inches, and they can weigh up to 77 pounds.

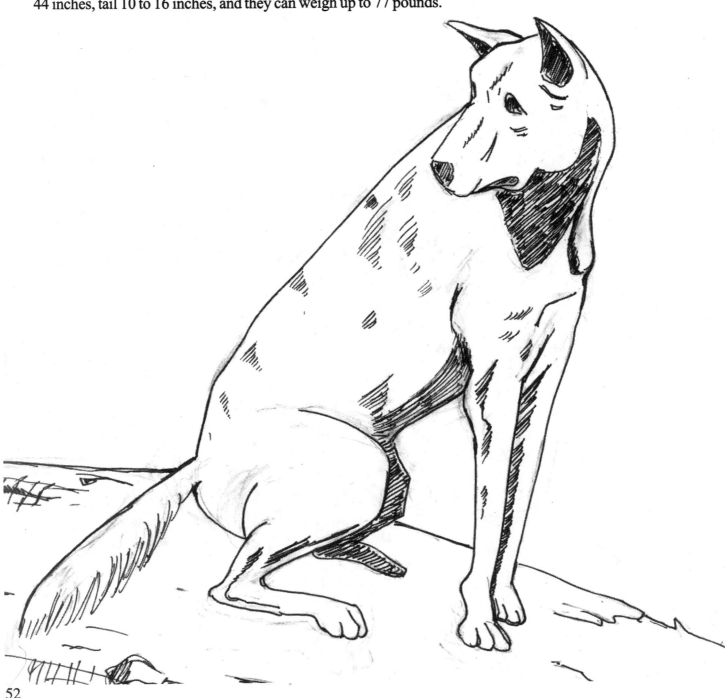

Start drawing an outline of the Baboon's head, ears, neck,
torso, legs, and feet.

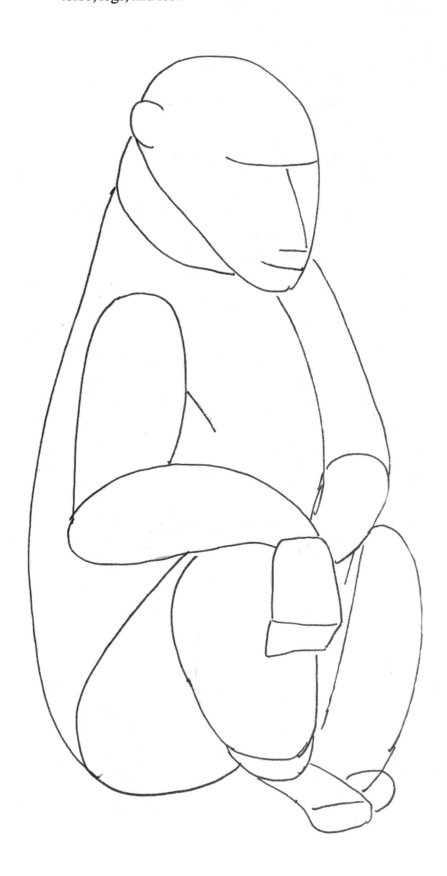

Begin shaping in the outline of the Baboon's head, ears, neck, torso, legs, and feet, for a more precise description of the total body.

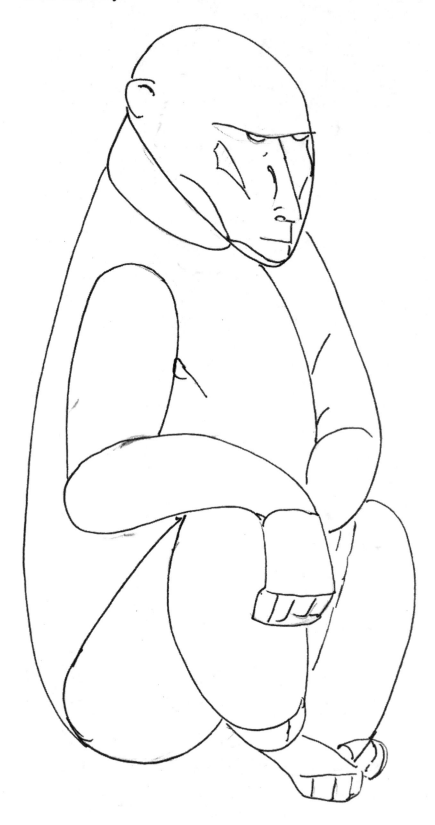

Get rid of any unnecessary lines add some hair, and then proceed to turn your drawing into another masterpiece.

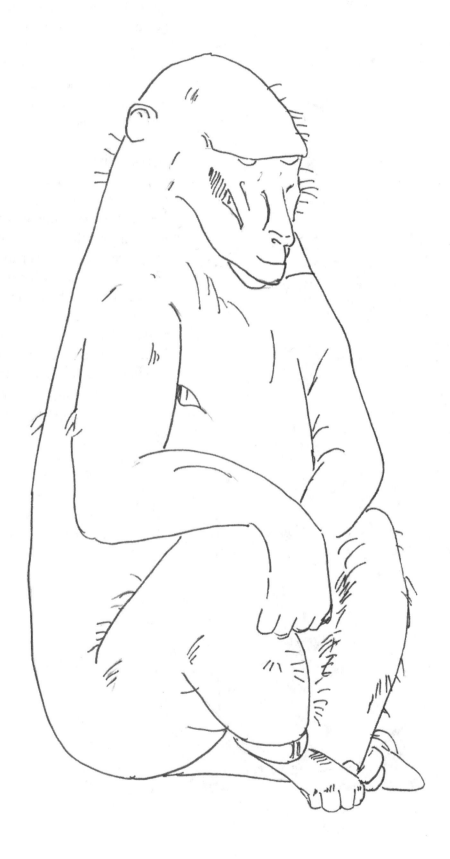

BABOON

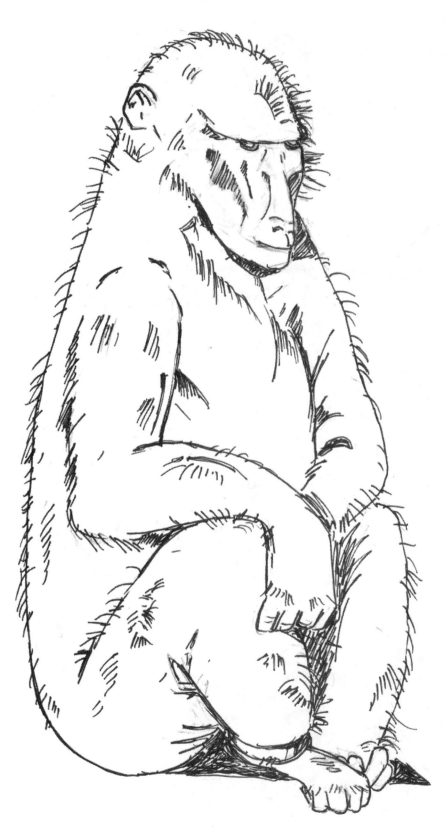

BABOON although a large monkey, is quite slender. Its coarse coat is dark olive-green, with the underside slightly paler and often bare. The length of head and body up to 40 inches, tail 27 inches, weight up to 100 pounds. They live in Senegal to Somalia and southward in Africa, and in southern Arabia.

Baboons live in large groups, numbering up to 150 - 200 individuals, in which is a strict hierarchical order. The size of the group depends on the availability of food and varies from habitat. When the group is on the move it can travel up to 6 miles a day. The young males take up positions in the front and rear of the group, with females, adult males, and young remaining in the middle. If attack, all the males will engage in fierce combat. Their last defense is to flee into trees. Baboons eat early in the day, feeding mainly on plant matter, but also eating small mammals and birds.

I started drawing the tree, and then proceeded with drawing an outline of the Slender Loris's head, torso, arms, legs and hands.

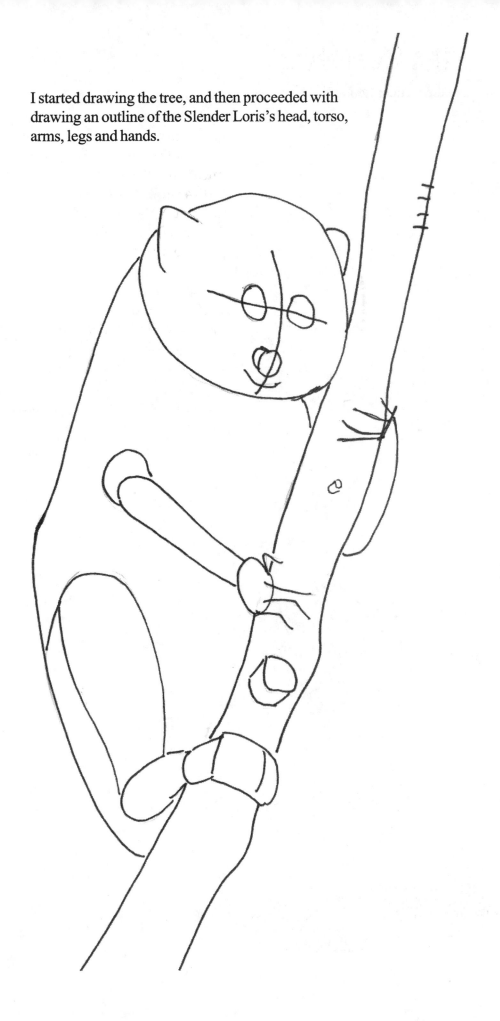

Begin shaping in the outline of the Slender Loris's head, face, ears, neck, torso, legs, and feet, for a more precise description of the total body.

Draw in some inside lines to add some contrast and shadow to the Loris, and then proceed to turn your drawing into another exceptional masterpiece.

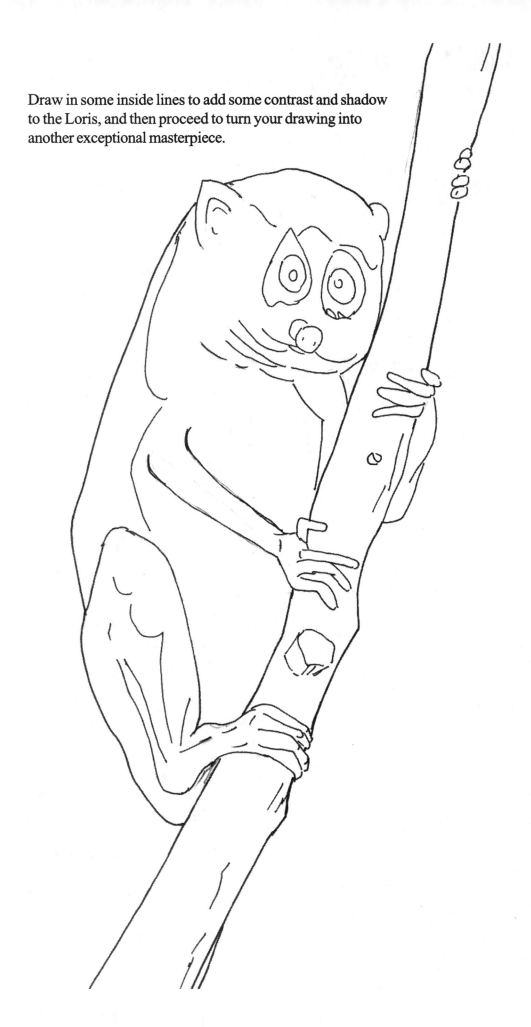

SLENDER LORIS

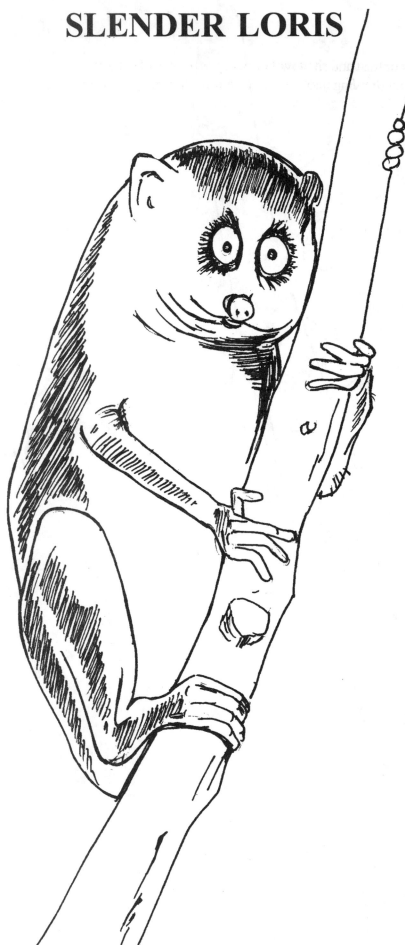

SLENDER LORIS is tail-less, with soft, dense fur that is brown, with the underside sliver-gray. The nose is pointed and the eyes are very large. The ears are round and prominent, and hairless at the edge. The hands and feet are prehensile. There are small flat nails on all toes except the second toe, which is reduced and has a specialized grooming claw. Length of and body about 10 inches, and can weight up to 12 ounces.

Found in Southern India and Sri Lanka, this is night creature, which spends the daylight hours in tree hollows or among the branches of trees, curled up tightly with head tucked between its hind legs, and its feet clinging to a branch. Its movements are very slow; it spends the hours of darkness moving among the branches of trees hunting insects, geckoes, and lizards. It lives a solitary life and is territorial; it soaks it hands and feet in its own urine (this activity is called "urine-washing") so that it leaves a scent wherever it goes, which helps it find its way as well as to mark its territory. A single offspring is born after a gestation period of about six months. At birth the Loris is covered with hair, and achieves independence from its mother after about a year.

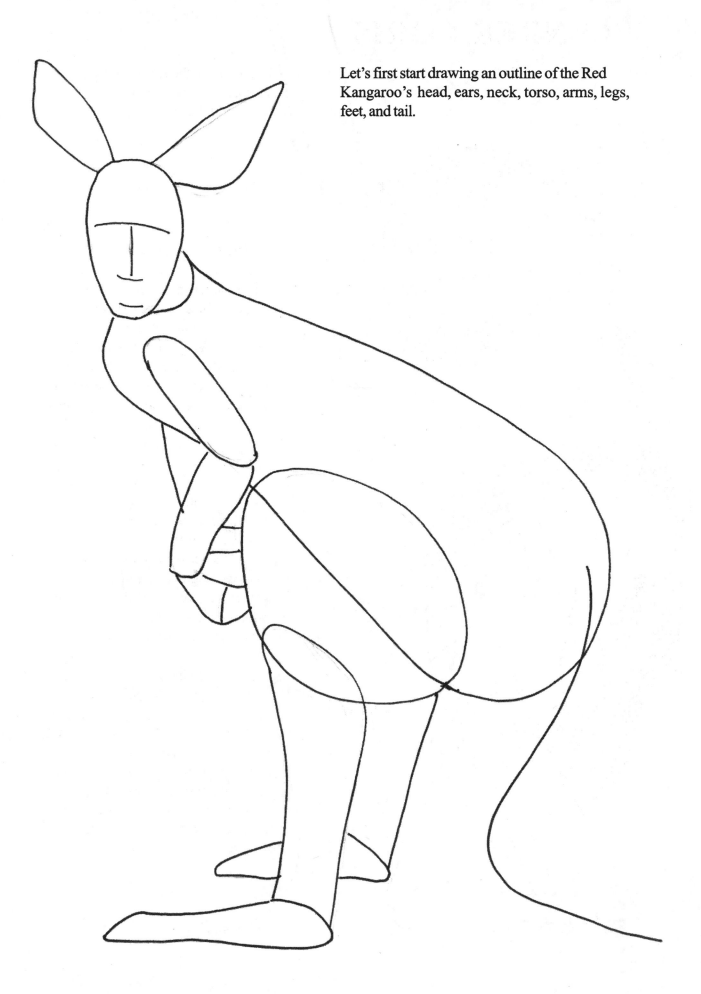

Let's first start drawing an outline of the Red Kangaroo's head, ears, neck, torso, arms, legs, feet, and tail.

Begin shaping in the outline of the Red Kangaroo's head, ears, neck, torso, arms, legs, and feet, for a more precise description of the total body.

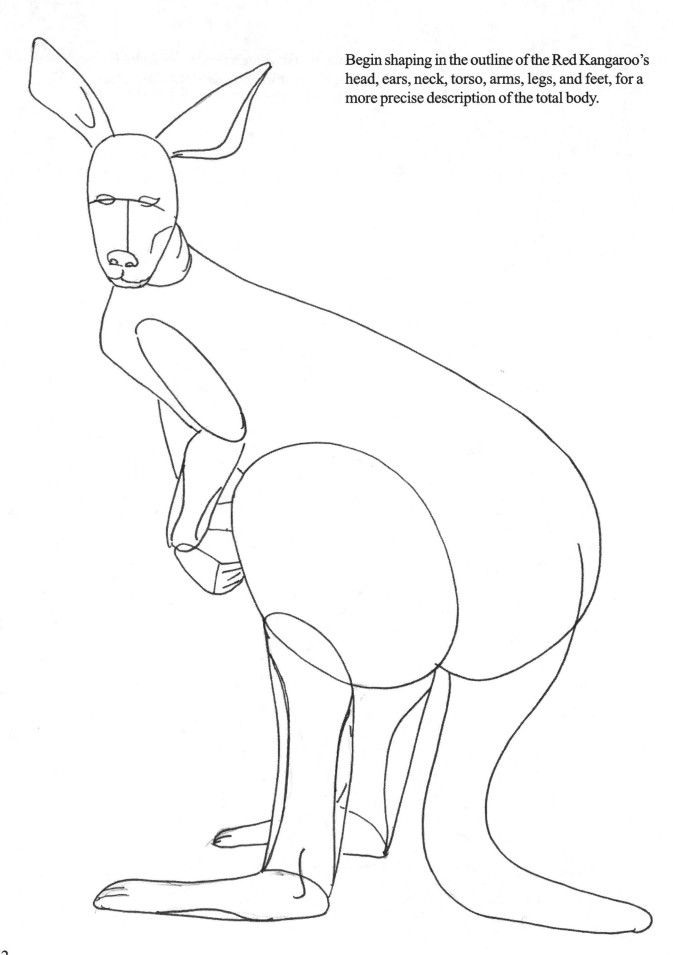

Draw in some inside lines to add some contrast and shadow to the Red Kangaroo's body to proceed to turn your drawing into an exceptional art piece.

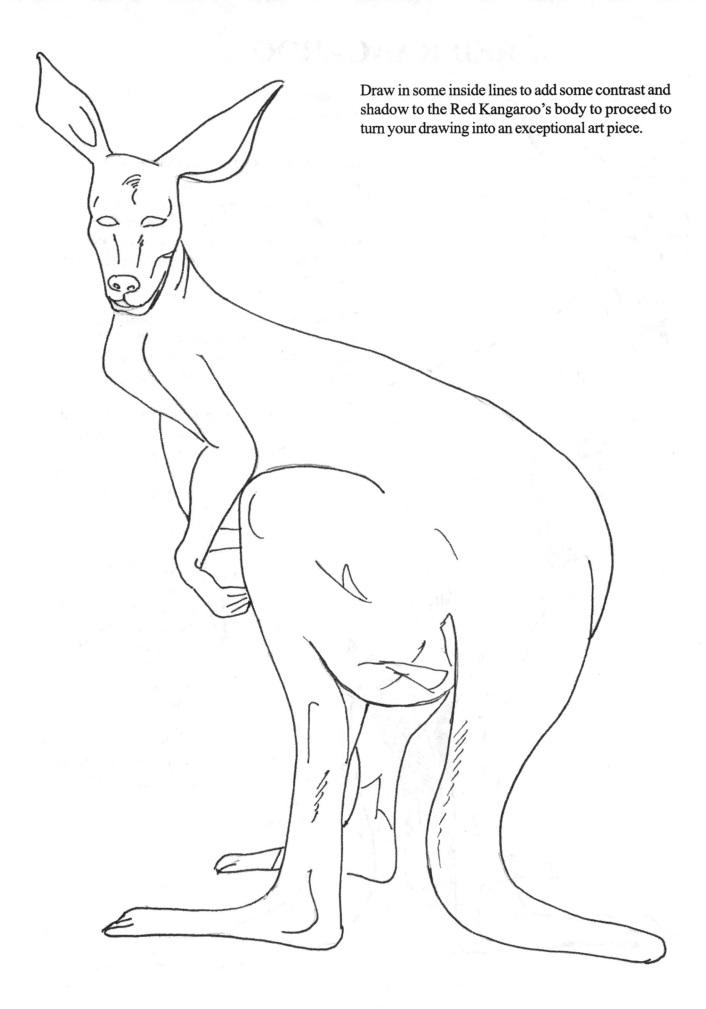

RED KANGAROO

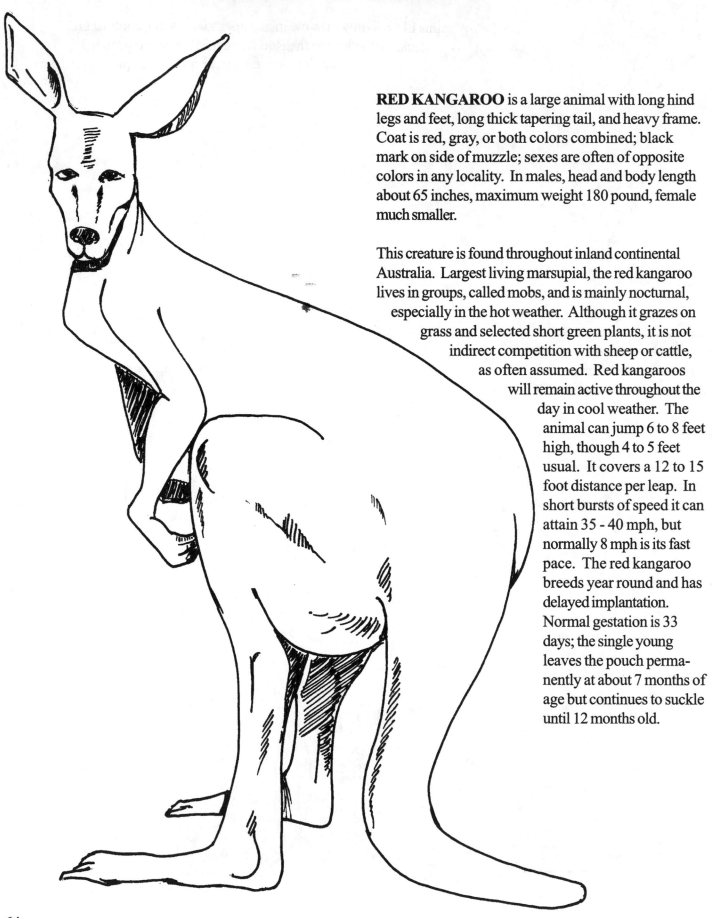

RED KANGAROO is a large animal with long hind legs and feet, long thick tapering tail, and heavy frame. Coat is red, gray, or both colors combined; black mark on side of muzzle; sexes are often of opposite colors in any locality. In males, head and body length about 65 inches, maximum weight 180 pound, female much smaller.

This creature is found throughout inland continental Australia. Largest living marsupial, the red kangaroo lives in groups, called mobs, and is mainly nocturnal, especially in the hot weather. Although it grazes on grass and selected short green plants, it is not indirect competition with sheep or cattle, as often assumed. Red kangaroos will remain active throughout the day in cool weather. The animal can jump 6 to 8 feet high, though 4 to 5 feet usual. It covers a 12 to 15 foot distance per leap. In short bursts of speed it can attain 35 - 40 mph, but normally 8 mph is its fast pace. The red kangaroo breeds year round and has delayed implantation. Normal gestation is 33 days; the single young leaves the pouch permanently at about 7 months of age but continues to suckle until 12 months old.

Let's get busy drawing this Llama. Let's start with an
outline of the head, ears, neck, torso, leg, and hoofs.

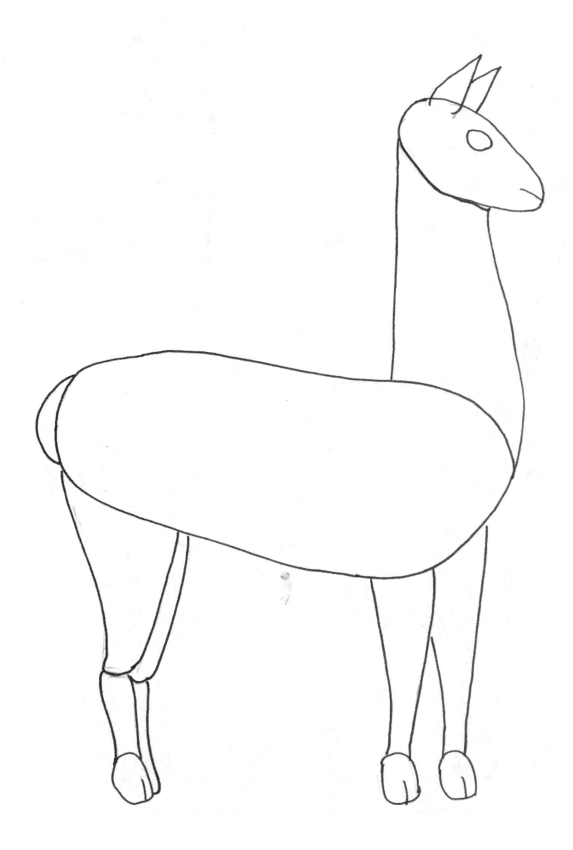

Begin shaping in the outline of the Red Llama's head,
ears, neck, torso, arms, legs, and feet, for a more
precise description of the total body.

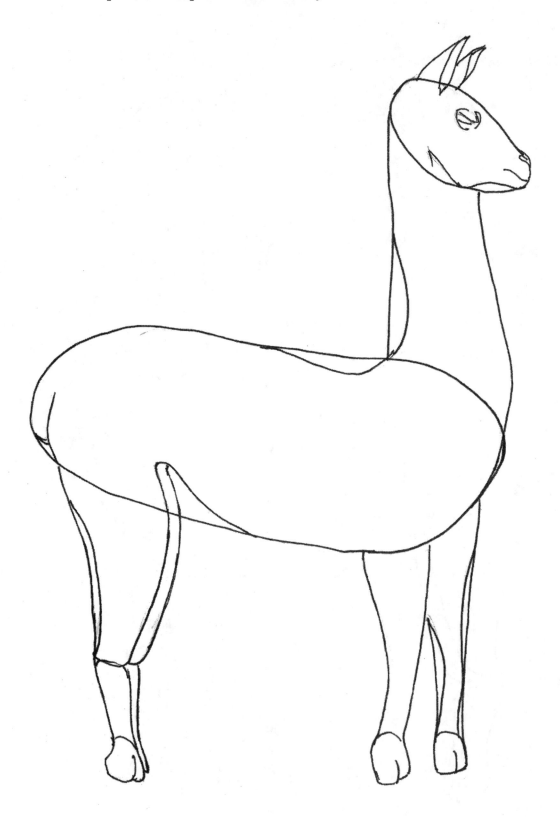

Get rid of any unnecessary lines add some hair, and then proceed to turn your drawing into one of your best works of art.

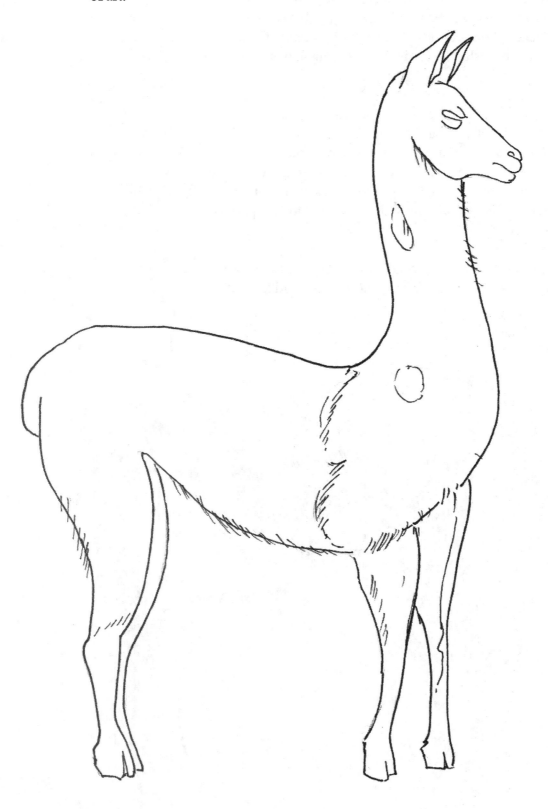

LLAMA

LLAMA the long shaggy coat varies in color from white all over through spotted or speckled, to brown black, or reddish brown all over. It is somewhat like the guanaco in appearance but stockier, with long and more varied coat texture and color. Length of head and body up to 6.6 feet, shoulder height 4 feet, weight over 290 pounds.

The llama is from South America, in the Andres and tends to live in small groups made up of a dominant male with a harem of about 5-10 females and their young. Young males are kept away the group and lead a bachelor existence. Breeding occurs in the spring, and after 10 months of gestation, the female gives birth to a single young. There no true wild llamas, all are domesticated and are used to transport goods at high altitudes.

As far as zoological systematics is concerned, this species still poses a problem. Some authors consider it to be a domesticated form of the guanaco.

Let's start drawing an outline of the Aardvark, the first
mammal in the dictionary. Begin drawing the head, ears,
neck, torso, legs, and tail

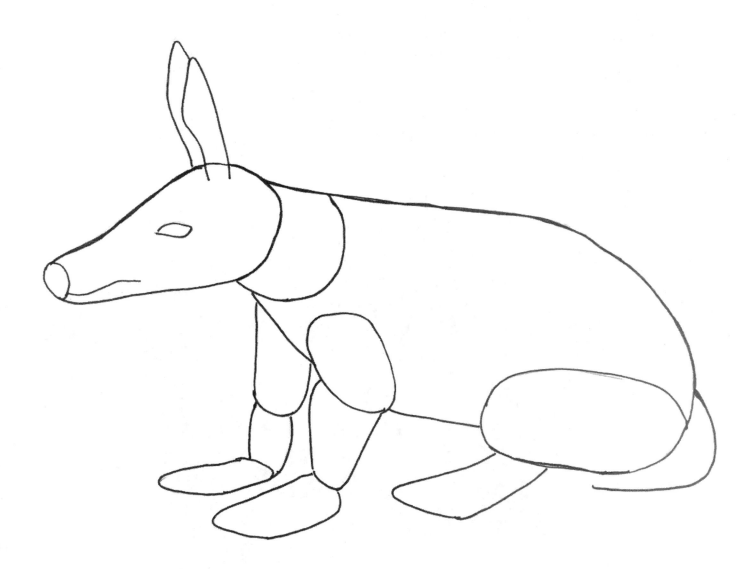

Now, let's define the various parts of the Aardvark's total
body by drawing within the outlines.

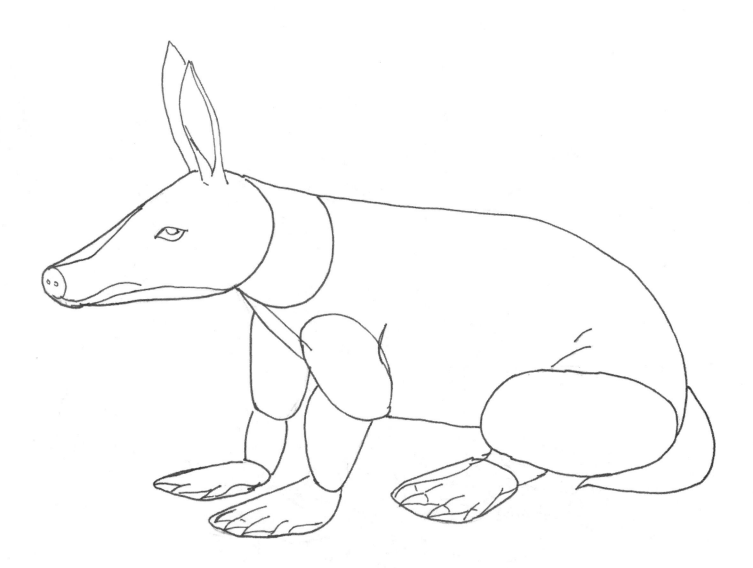

You can erase any lines not needed, draw in more details such as
the hair and lines for shadows.

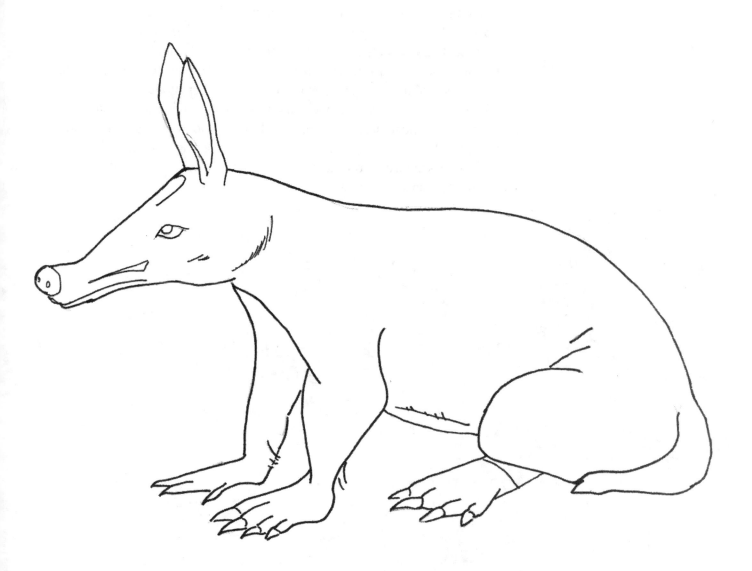

AARDVARK

AARDVARK this fairly large creature has a distinctive shape, with a curved back and a rather pig like snout. Its ears are long and tough; it has strong feet with four toes on the front foot and five on the back. All toes have large claws. The grayish skin is thick and bare except for a few hairs. Length of head and body is 40 - 60 inches, tail 18 - 24 inches, and weight 175 - 220 pounds.

The aardvark resides in Africa south of the Sahara. They inhabit the grasslands, and open forests where the ground is soft. The aardvark is a nocturnal creature and very difficult to observe. It spends the day in its burrow. It is a very efficient digger, and can disappear underground rapidly. The tunnels are sometimes very long and complex, with numerous openings, but they invariably end in a large chamber. It feeds on termites, which it sucks into the mouth with its sticky tongue. It is a solitary animal, except when the female is accompanied for a while by one or more young. Gestation lasts 7 months, after which a single offspring is born. Although the young is nursed for only a few months, it will often remain with its mother for many more months.

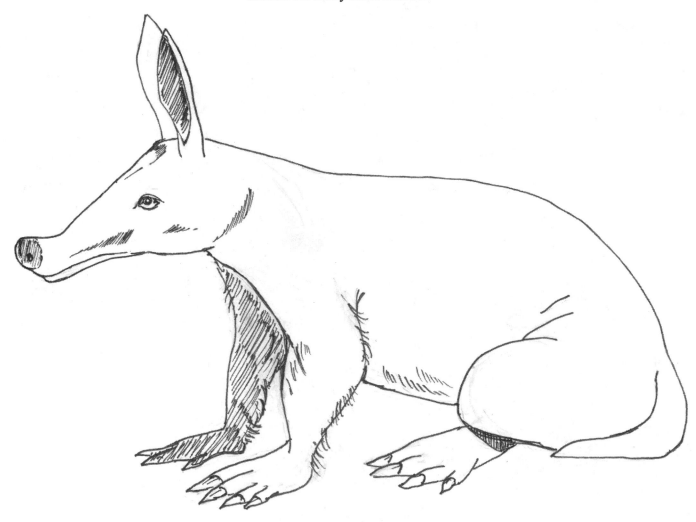

Start drawing an outline of the Gorilla's head, neck, torso,
arms, legs, and feet.

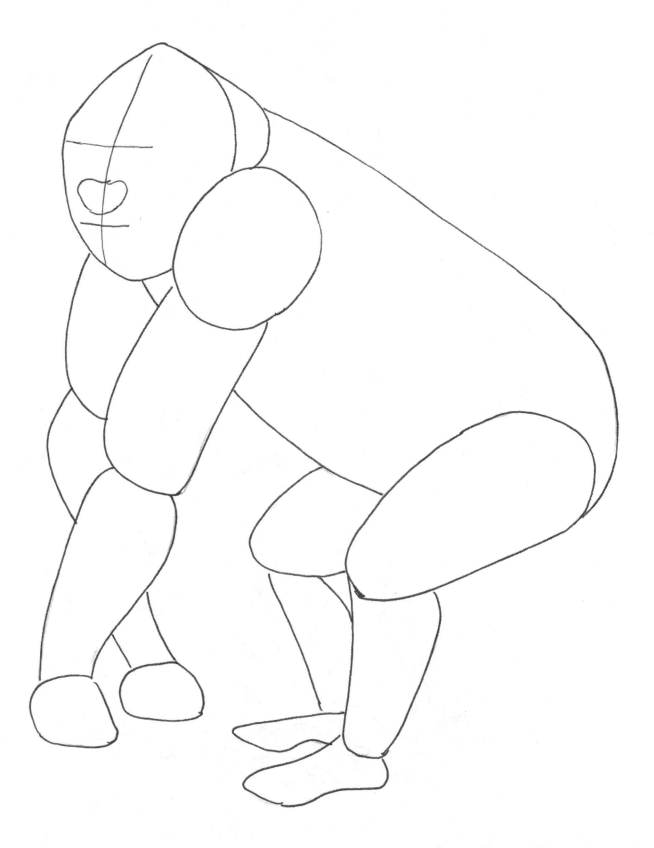

Begin shaping the Gorilla's body from head
to toe for a more definitive look.

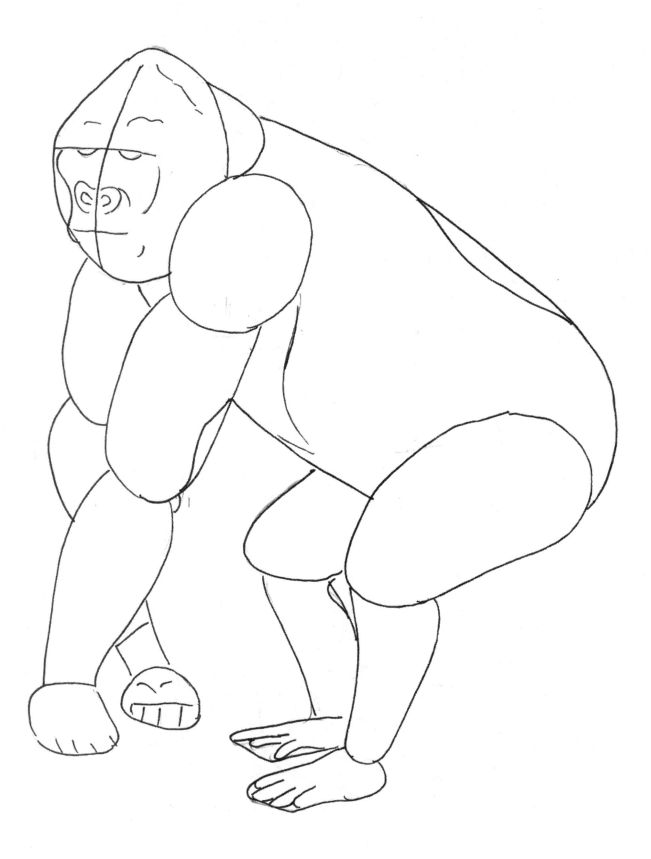

Now, let's define the various parts of the Gorilla's body by drawing within the outlines to create more detail.

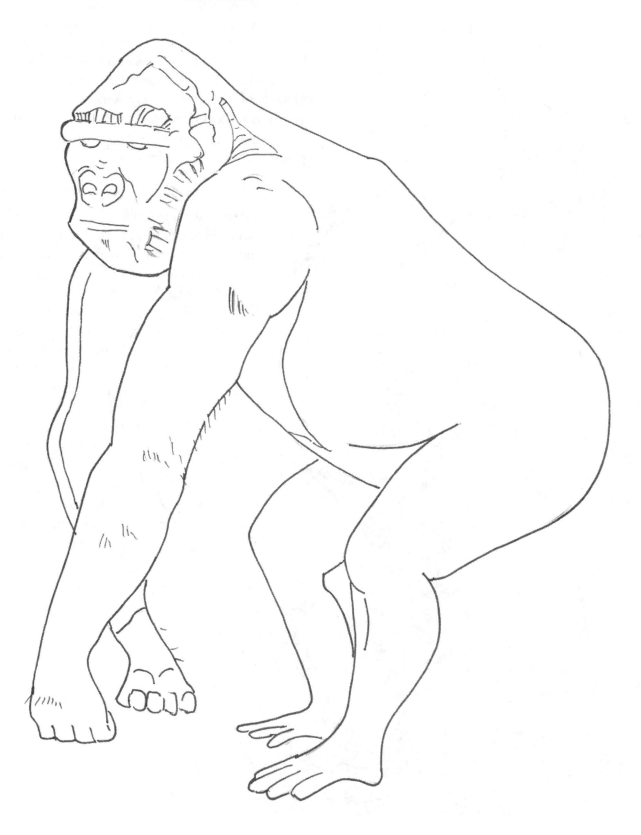

GORILLA

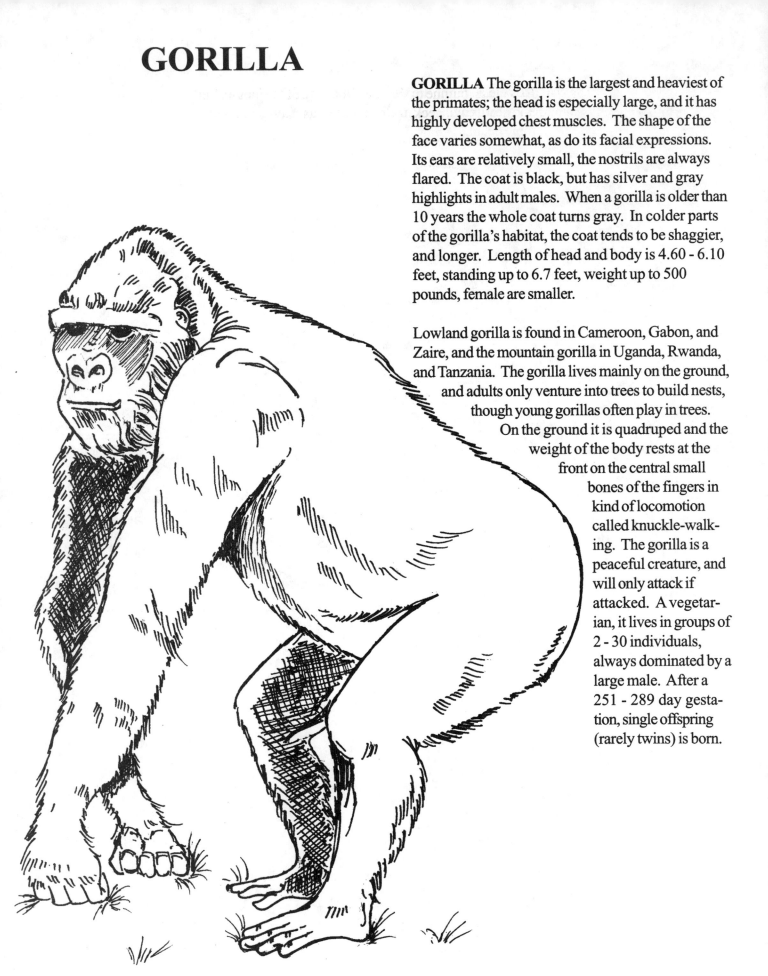

GORILLA The gorilla is the largest and heaviest of the primates; the head is especially large, and it has highly developed chest muscles. The shape of the face varies somewhat, as do its facial expressions. Its ears are relatively small, the nostrils are always flared. The coat is black, but has silver and gray highlights in adult males. When a gorilla is older than 10 years the whole coat turns gray. In colder parts of the gorilla's habitat, the coat tends to be shaggier, and longer. Length of head and body is 4.60 - 6.10 feet, standing up to 6.7 feet, weight up to 500 pounds, female are smaller.

Lowland gorilla is found in Cameroon, Gabon, and Zaire, and the mountain gorilla in Uganda, Rwanda, and Tanzania. The gorilla lives mainly on the ground, and adults only venture into trees to build nests, though young gorillas often play in trees. On the ground it is quadruped and the weight of the body rests at the front on the central small bones of the fingers in kind of locomotion called knuckle-walking. The gorilla is a peaceful creature, and will only attack if attacked. A vegetarian, it lives in groups of 2 - 30 individuals, always dominated by a large male. After a 251 - 289 day gestation, single offspring (rarely twins) is born.

Let's start drawing an outline of the Loin, the king of the jungle. Let's begin with the head, ears, neck, torso, mane, legs, paws, and tail.

Begin shaping and forming the outline of the Loin's body from head to toe for a more definitive look.

You can erase any lines not needed, draw in more details
in the face, mane, and shadow lines.

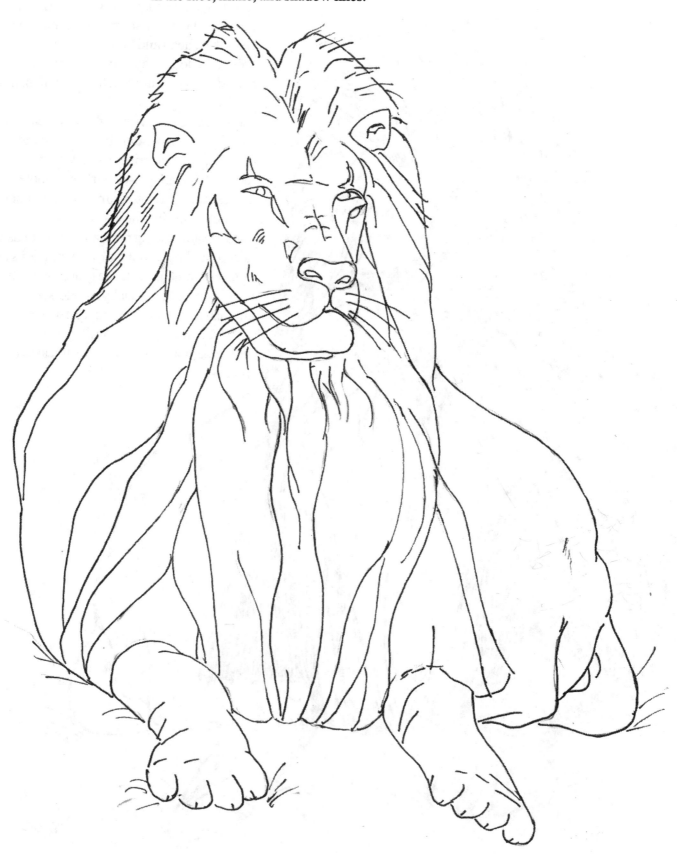

LION

LION the normal color is tawny yellow but varies from gray to ochre and can be blackish, the female has paler coloring, especially on the throat and on the underside of the body. The length of mane, found only in males, may be associated with harshness of the local climate. Length of head and body in males is 5.6 - 6.3 feet, tail about 3 feet, and weight 330 - 550 pounds. Female are much smaller than males.

Lions can be found throughout Africa and southern Asia to India. Lions are social animals, living in prides usually made of one or more adults males, two or more females, cubs, adolescents. It hunts mainly at night, but is also active during the cooler part of the day. It hunts by ambushing prey, and does not usually pursue it. The resources of several lions are often combined; while the group stalks the prey, a single lion, usually a lioness, may ambush it. Gestation lasts for 105 days, after which the female gives birth to 2 - 4 cubs that will remain with the group for at least 18 months.

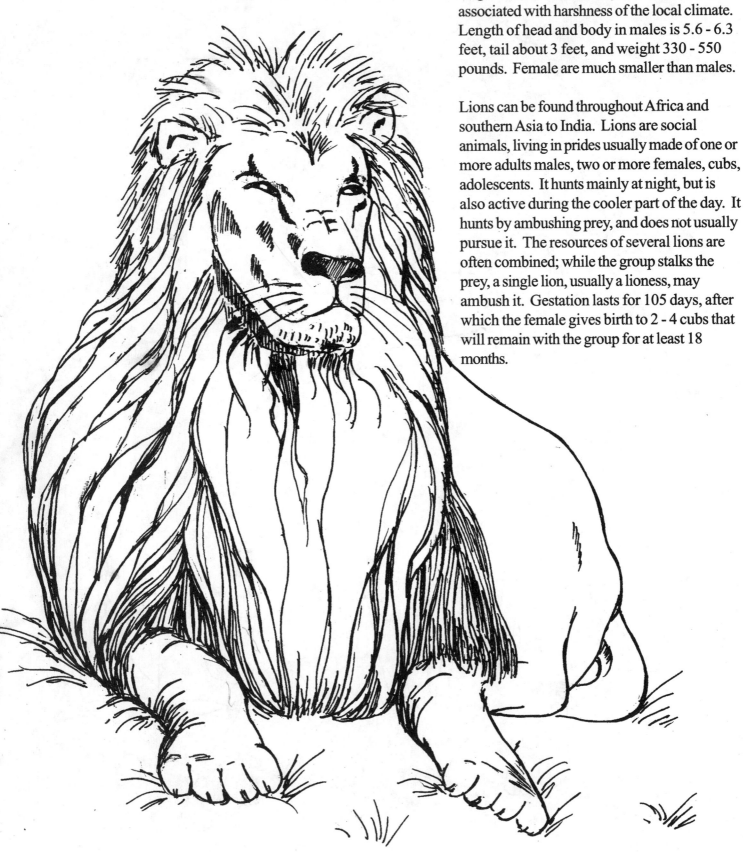